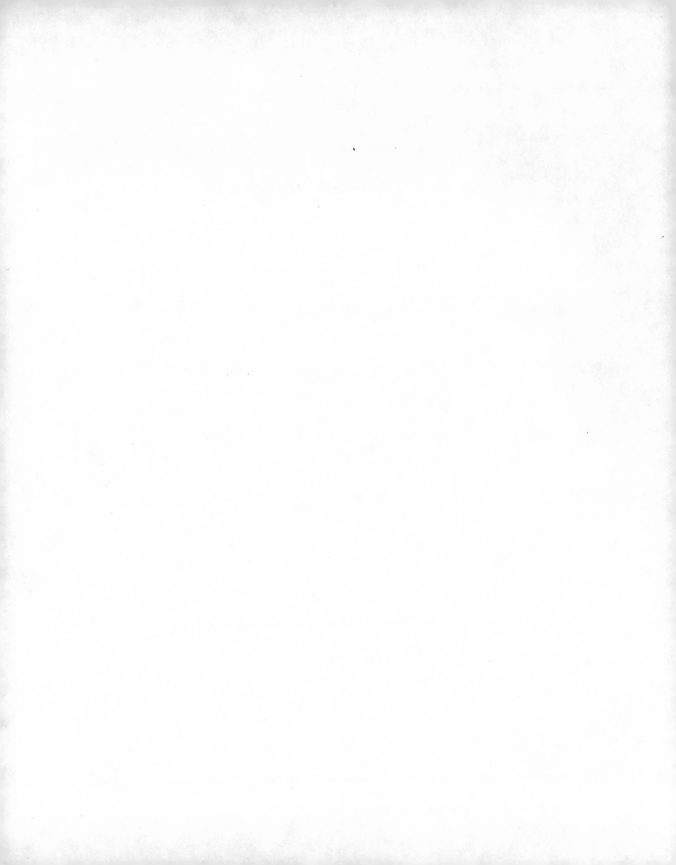

SAY "CHEESE"!

SAY "CHEESE"!

Looking at Snapshots in a New Way

❧❦❧

GRAHAM KING

DODD, MEAD & COMPANY • New York

1. *Walker Evans. American. 1936. To symbolize the poignancy of an Alabama sharecropper's life during the Depression years, one of America's most outstanding documentary photographers photographed this pair of snapshots tacked to the wall of the family shack.*

Copyright © 1984 by Graham King
All rights reserved
No part of this book may be reproduced in any form
without permission in writing from the publisher.
Published by Dodd, Mead & Company, Inc.
79 Madison Avenue, New York, N.Y. 10016
Distributed in Canada by
McClelland and Stewart Limited, Toronto
Manufactured in the United States of America
Designed by Claire Counihan
First Edition

Library of Congress Cataloging in Publication Data

King, Graham.
 Say "cheese"!

 Bibliography: p. 211
 Includes index.
 1. Photography, Instantaneous. I. Title.
TR592.K56 1983 770 83-20828
ISBN 0-396-08354-4

*To the thousands of anonymous photographers
and sitters who have contributed to
my collection of snapshots, and thus to most
of the illustrations in this book, I offer
my gratitude.*

*For their help in assisting me to
assemble this book I also wish to thank
Dorinda Freeman, Cathy Cresci, John Sabatino,
Debbie Watkins, Harry Storey, and my editor, Jerry Gross.*

CONTENTS

❧

Acknowledgments

The following photographs reproduced in this book appear by courtesy of the following photographers, galleries, libraries, and collections:

(69) © Museum of Fine Arts, Boston. Gift of Robert Treat Paine II. (72) Barnardo Photo Library, London. (84) © National Portrait Gallery, London. (85) Gernsheim Collection, Humanities Research Center, The University of Texas, Austin. (112) Photo Archive Pictures Inc., New York. (113) © Wandsworth Photographic Service, London. (123) National Gallery of Victoria, Melbourne. Felton Bequest, 1922. (125) © National Portrait Gallery, London. (142) © Peter Hunter. Courtesy of La Photogalerie, Paris. (143 and Frontispiece) Collection of Library of Congress, Washington, D.C. (155, 157) Metropolitan Museum of Art, New York. The H. O. Havemeyer Collection. (156) © Museum of Fine Arts, Boston. (159) Sterling & Francine Clark Art Institute, Williamstown, Mass. (160) National Art Center, New York. (162) Collection of Whitney Museum of American Art, New York. (163) Courtesy of Lunn Gallery, Washington, D.C. (166) © Philip Trager, 1977. (170) Isabella Stewart Gardner Museum, Boston. (178, 179) © Henri Cartier-Bresson. Magnum Photo Library, New York. (189) © Monique Jacot. Courtesy of Opsis, Paris. (190) © John Wall. Courtesy of Co-optic, London. (191, 200) © Henry Wessel, Jr. (194) © Andre Gelpke, 1979. (197) © Marcia Resnick, 1975. (201) © Lee Friedlander. (203) © Thomas F. Barrow. (205) © Christopher Meatyard (207) Courtesy of The Pace Gal-

lery, New York. (208B, 208G) Courtesy of Middendorf Gallery, Washington, D.C. (208C) © Gardner Botsford, 1971. (208D) © Joel Meyerowitz. (208E) Collection of The Museum of Modern Art, New York. (212) City of Birmingham Public Libraries Dept. (213) © Christian Boltanski, Paris. (214) © William DeLappa. (215, 216) © Braco Dimitrijevic. (217) © Ray K. Metzker. Courtesy of Laurence G. Miller Gallery, New York. (219) Eric Pollitzer, New York. Courtesy of O. K. Harris Work of Art, New York.

Introduction

I snap, therefore, I am.
—René Descartes de Visite

Is there anybody alive today who hasn't been photographed? Perhaps in some remote corners of the world, where picture-taking is taboo, there are humans lacking a two-dimensional counterpart, but the practice of taking photographs and being photographed is just about universal.

Making photographs, to the overwhelming majority of us, means taking snapshots. A veritable ocean of snapshots already exists, from the nostalgic sepia images of our ancestors and the Verichromes and Panchromatics of our parents to the Kodachromes and Polaroids of recent years. Millions more roll from processing plants every day, in a ceaseless tide.

It's a phenomenon that, until a few years ago, concerned few but the manufacturers of cameras and film. But as we've become increasingly conscious of the significance of photography, and of the complex role it plays in our lives and in our perception of the world about us, we've begun to pay the humble snapshot a little belated attention.

Susan Sontag, in her collection of philosophical essays, *On Photography*, summarizes the generally held view that "instead of just record-

ing reality, photographs have become the norm for the way things appear to us, thereby changing the very idea of reality and of realism." To this I would add that the snapshot, almost exclusively, has revolutionized our way of seeing the world. We might gaze for many minutes at a photograph in a magazine, for example, but it cannot have the force or make the same impression as a snapshot we have taken ourselves. Our family albums serve as primers to a greater awareness of photographic images, our own lives, and our past and present cultures. As American historian John Kouwenhoven comments, "The cumulative effect of one hundred and thirty years of man's participation in the process of running amuck with cameras was the discovery that there was an amazing amount of significance, historical and otherwise, in a great many things that no one had ever seen until snapshots began forcing people to see them."

For some 150 years now, photography's ocean has been fed by a constant Niagara-like cascade. Historians have dabbled along its shores and have meticulously examined some of its more obvious and outstanding features. But the ocean itself remains virtually unexplored. An almost boundless repository of anonymous human artifacts, it is infinitely more comprehensive and no less revealing than the treasures of the pharaohs we study so assiduously.

What has kept this repository of visual record so large is, perhaps, the fact that snapshots are so utilitarian, and thus so omnipresent. For every ten million destroyed, a million probably survive, and that's still a lot. The survivors have been left untouched. They have not appealed to the collector instinct; they have been *infra dig* to the art world; and the lack of any progression in technique and style has discouraged the historian's interest. Only recently has today's amateur family photographer cared more about technique and composition than did his counterpart of eighty years ago. And despite his more sophisticated equipment he still takes the same kind of photographs of the same range of subjects, and makes equally silly mistakes.

But we may at last be witnessing a change in the purpose of taking snapshots. For past generations this purpose was clearly defined—to prove something ("That's me with Bill on the beach at St. Tropez"); to record something ("That's Jeremy. See his curly hair as a baby?"); and to immortalize something ("That's Helen at her graduation/ wedding/twenty-first"). Now, with foolproof cameras, motor drives, cheap film, and inexpensive foreign travel, taking snapshots is becoming more of an activity to occupy one's time, or to justify the owner-

ship of an expensive Minolta. When one can zap off a dozen exposures or produce an instant true-color image before an impressed audience, the purpose of taking snapshots becomes less explicit.

In the past decade or two, many professional photographers have come to regard snapshots with wary respect. Lisette Model's assessment is typical: "I am a passionate lover of the snapshot, because of all photographic images it comes closest to the truth. The snapshot is a specific spiritual moment."

But respect is one thing; recognition and the assimilation of the snapshot into the aesthetic fabric of photography is another. One of the drawbacks is that snapshots audaciously subvert and certainly confuse the connection between art and value. In his essay "Understanding the Photograph," critic John Berger states, "By their nature, photographs have little or no property value because they have no rarity value. The very principle of photography is that the resulting image is not unique, but on the contrary infinitely reproducible." Written in 1974, the statement is already out of date; the photo establishment now has several solutions to this objection—for example, limited editions with the negative canceled afterwards. Nor does it take into account the unique Polaroid image, or indeed the anonymous snapshot, the negative of which has been irretrievably lost. The snapshot, in fact, tosses a hefty contradiction into the well-oiled commercial apparatus of art photography.

By present-day common consent, the snapshot has no intrinsic value as a collectible. You are certainly unlikely to find snapshots, unless they have important historical associations, offered at any of the auction houses now conducting sales of photographica. There are sound reasons for this. Probably the most noteworthy is a philosophical one: the moment a snapshot acquires a commercial value, it ceases to be the humble, commonplace "found" artifact that it must essentially be. Selection and isolation will, of course, make an anonymous snapshot "special," but only in the way we might pick up a seashell because it in some way appeals to us, while leaving a million other similar shells on the beach.

That's the daunting thing about snapshots: there are literally billions, possibly trillions, of them, and they are almost all unique. Only a tiny percentage are ever reprinted from their negatives, and even then the reprint is likely to be different in some way.

Yet, as I hope I convincingly demonstrate in this book, many snap-

shots (and that could mean millions) can possess the qualities we look for in a work of art. A discerning eye is all that's required to enable a snapshot to jump its class barrier. But, as John Berger points out, "In the world as it is, no work of art can survive and not become a valuable property." There's the contradiction.

So snapshots, you will find, concern the photography establishment not at all. Aping the art world, the photo-collecting and curatorial establishment is preoccupied with the orderly maintenance of a market and the "museumization" (as one New York art critic put it) of a narrow range of accepted images. Predictably, pretensions and fads abound that have little to do with photography's broad role in our lives. So don't be surprised if the plebeian snapshot is kept permanently waiting outside the secure doors of contemporary photographic interest.

Consequently the snapshot collector need hardly worry about his specialty being priced beyond his reach. In assembling a collection of some ten thousand snapshots from various countries, from which the illustrations in this book have been mostly drawn, I can't remember paying more than ten dollars for a single image or forty dollars for an album, with the majority costing only a few cents apiece. Not for the snapshot enthusiast the world of the glossy catalog, gallery parties, and acid-free mounting board; instead the less glamorous domain of the attic, the flea market, the postcard dealer, and the shoebox. And hopeful expectation.

It is still possible, by luck, discovery, observation, and interpretation, to make photographic history. Unlike the well picked-over field of art history, photographic masterpieces are constantly being turned up. The experience of Yorkshire English teacher Colin Gordon is an inspiring example. From a market stall one Saturday morning in 1975 he bought six hundred glass and film negatives for five pounds, all of snapshots recording the life of a middle-class Yorkshire family from the 1880s to the 1920s. The find proved to be a gold mine of social and photographic history—and also the basis of a best seller (*A Richer Dust—Echoes from an Edwardian Album*, Elm Tree Books, London, 1978).

Similarly, in the last few years, we have witnessed the rediscovery and recognition in the United States of entire bodies of work by the gifted nineteenth-century amateur Caroline Sturgis Tappan, the provincial professionals Mike Disfarmer and Joe Steinmetz, the itiner-

ant Howes Brothers, and photography's "Toulouse-Lautrec," the New Orleans bordello documentarian, E. J. Bellocq. Unknown to scholars of a decade ago, they're now permanent fixtures in the strata of photo archeology. And among that strata, like loose grains of sand awaiting some tidal surge to form them into layers and patterns, lurk those several billion snapshots. An unprejudiced eye and, in some cases, an imaginative mind are all that's required to coax them to reveal their secrets.

For me, the secrets were a long time coming. Some blind sense drew me to snapshots and I collected them wherever I went, by the thousands. But while my collector's instinct was gratified, questions always nagged: why did some images have the power to leap from the pack to captivate, to charm, to haunt the memory? Why did some images— anonymous people, places, and events torn from their historical and personal moorings—seem to possess the assurance and completeness we experience in a true work of art?

Then there was the dilemma of consistency. It is fairly easy to rationalize why some images appeal to some people but not to others. But in a series of experiments I found that certain images possessed something akin to universal appeal. I would select ten of my favorite snapshots, mix them with ten others, and then ask friends to choose the ten they liked best. In most tests seven or eight of my original ten would be included in their choices. Why was this?

And why were people fascinated by snapshots anyway? Almost without exception, once exposed to my collection, visitors with no more than a passing interest in photography and snapshots would pore over these anonymous images for hours, often making surprising and original observations.

Are we all merely voyeurs? Are we, with our privileged peeking into the intimate corners of other people's lives, stirring chords of recognition in our own? Somehow, many snapshots seem to have the power to connect and commune—but why? As the questions and mysteries accumulated, so my curiosity increased and also my frustrations. These were not questions one might find answered in any encyclopedia. Nor were the mysteries solved by running to the hundreds, indeed thousands, of photographic books that have flooded a hungry market during the past couple of decades.

Considering the universality of snapshots and their presumed im-

portance in our lives, literature on the subject is woefully meager—indeed almost nonexistent. This is a mystery in itself. And most of what does exist has been contributed in the past decade, springing perhaps from Professor John Kouwenhoven's 1972 lecture in a *Photographic Points of View* symposium at New York's Metropolitan Museum of Art. This was a watershed statement on the snapshot phenomenon with a ringing, unequivocal conclusion: "Willingly or unwillingly we are participants in a revolution of seeing which began when the first snapshots were taken about a hundred years ago."

Since then I have scrambled after whatever crumbs of snapshot scholarship have fallen from photography's fastidiously laid table. The ten years of scrambling, in fact, led to my resolve to attempt this comprehensive but also, I hope, critical, readable, and even amusing evaluation of the snapshot.

Although I have taken this account of the snapshot right up to the introduction of the industry's latest toys—the 3-D and talking cameras—the reader may note that I have chosen to illustrate it with a discernible weighting toward pre-1950 images. This is a matter of personal choice, nothing more. I could have used contemporary images exclusively, and if I had, I'd have used them to make the same points illustrated instead by vintage images. I find the patina of nostalgia adds an extra appeal to an image, that's all.

Another fair criticism of this book is that its focus is ethnocentric. I can, however, attest that taking snapshots is done for the same reasons and that snapshots look basically the same in European countries, in the United States, and in Australia. But the book takes no account of family photography in, for example, Third World countries (where photography may be a taboo), nor in China and India. Nor in Japan, which today seems to be one vast factory producing cameras for the rest of the world. Surprisingly, for a culture so idiosyncratic in the rigidity of its graphic tradition, photography there has borrowed virtually nothing from Japan's own past and everything from the West. There is none of the formalized realism, dynamic composition, and delicate sense of design that characterizes its traditional art; a Japanese family snapshot of the twentieth century is essentially the same as a Western snapshot.

While I've attempted to be comprehensive in scope, this book certainly won't be the last word on the snapshot. Right now, Kouwenhoven's "revolution of seeing" is changing gear. Images from

new technologies have yet to make their universal mark, and some of them may have far-reaching effects on humanity's 150-year love affair with the camera. But if this account achieves nothing more than to make you just a little more observant when you next view some snapshots, or urge you to think a little about them, or simply to help you get more enjoyment from them, then my main intention will have been realized.

SAY "CHEESE"!

1

⚜

"You Press the Button . . .
. . . and We'll Do the Rest."

—GEORGE EASTMAN

A Short History of the Snapshot

ALTHOUGH PHOTOGRAPHY WAS INVENTED IN 1829, the snapshot as we know it has been with us for only a century. A snapshot implies something that is shot or captured instantaneously, an action impossible with early cameras and film. The world's first photograph required an exposure of nine hours, and even Fox Talbot's later, popular calotypes required that sitters immobilize themselves for up to a minute and sometimes more. With a few notable exceptions, early Victorian photographs were as glacial and unbending as the prevailing morality. And the extensive paraphernalia necessary for even a simple outdoor photograph was enough to cripple both the backs and the enthusiasm of all but the most determined amateurs.

Even had it been possible, the very *idea* of a snapshot was little understood in those early days. Most photographers plagiarized academic painting, while portrait photography took its cue from the Old Masters. Like surgery and dentistry, a studio sitting was something of an operation, and not necessarily painless. Subjects dressed in their Sunday best, with fixed and glazed expressions, stiffening muscles, heads held in the grip of neckclamps, and waited for the magic emulsion to harden.

None of this, however, impeded the progress of the new "high

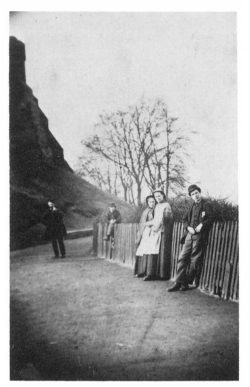

2. Snapshot. Albumen print.
English. c. 1880. A nineteenth-
century snapshot—if an
exposure time of one or two
seconds qualifies. Such a photo-
graph could only be achieved
with posed subjects; the figure
on the left moved and is
consequently blurred.

3. Amateur photograph.
Albumen print. Amer-
ican. c. 1870. When
everyone cooperated,
photographic images of
considerable beauty
could be obtained. But
candids as we know
them were still several
decades in the future.

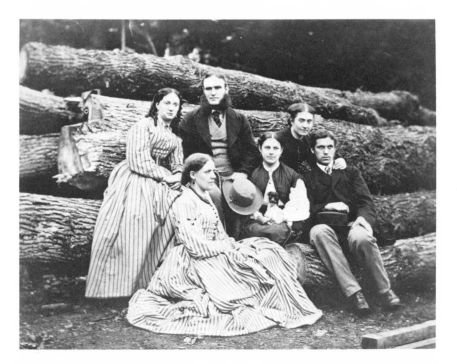

art"—jokingly so-called because most of it was conducted in glass houses constructed on the roofs of buildings for the maximum natural light. By the 1860s, every city, town, and village had its photographer, and even outlying hamlets were visited regularly by photographic vans. When the calotype gave way to the albumen plate, which used a base made from the whites of eggs, one plate manufacturer alone used eighteen million eggs in a single year. Fashion followed fashion. In the 1850s the stereoscopic craze provided every middle-class parlor with an armchair Cook's Tour. For the first time people at home could see the world's wonders as they really were: the pyramids in Egypt, Roger Fenton's remarkable photos of the Crimean War, Mathew Brady's pictorial coverage of the American Civil War.

4. *Snapshot. Albumen print. English. c.1895. With the faster, more portable dry plates, Victorian amateurs could capture their subjects in a more relaxed and natural manner.*

5. Tintype miniature. English. c.1890. Before the universal snapshot, the cheap tintype "Gem" was the favorite keepsake of the masses.

Then along came the small *cartes de visite* photographs—eight or a dozen portraits of a person to a sheet, but cut up and mounted on cards and exchanged between families by the million. Photographs of famous personalities were sold at a premium. Mayall's *cartes de visite* portraits of Queen Victoria, for example, were sold by the hundred thousands to citizens eager to own a true likeness of their beloved monarch.

But all this activity was largely in the hands of the professional and devoted amateur, until, in 1878, dry plates were invented which accepted an image in a second or less. The term "snapshot" entered the language, and so did a name.

6. Tintypes. American. c. 1880. As with today's snapshots, nineteenth-century miniatures were preserved in albums. The image, on an emulsion-coated thin sheet of iron, was taken and developed on the spot within minutes. The process was still used by street photographers until 1940.

7. Tintype snapshot. English. c. 1890. The portability of the tintype apparatus made it ideal for outdoor photographs of the snapshot kind.

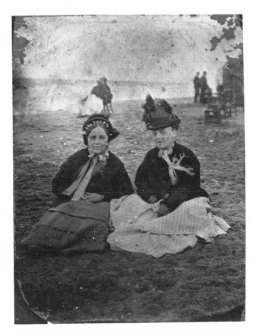

That name is indelibly associated with snapshots: Kodak. In fact, the name Kodak in its many manifestations—Brownie, Instamatic, Verichrome, Kodachrome, Ektachrome—has been synonymous with amateur photography for over a century.

The Kodak story began in 1878 with the invention and manufacture, by a young New York photographer named George Eastman, of gelatin dry plates. Previously, photographers had to coat glass plates—called wet plates—as they took their pictures, then rush them into a portable but cumbersome darkroom tent to develop the plate. This alone explains why, among the images taken before the 1880s, there is a dearth of the happy, humble, relaxed, and candid photographs we ordinarily call snapshots.

The portable, storable, and convenient gelatin dry plate didn't change things a lot, but Eastman's first camera certainly did. It was introduced in 1888 and was called the Kodak camera. It was the progenitor of the family box camera and was factory-loaded with a roll of film for a hundred circular pictures. It sold for twenty-five dollars and to get your photographs you returned the entire camera and film to the factory, where it was reloaded. Within a year some thirteen thousand Kodak cameras had been sold, and the company was processing seventy-five hundred of the circular prints a day. Among these images you will find the world's first genuine snapshots. Not many, however, have survived, and because of their rarity they are among the few types of snapshots that have a market value. (Prints from the 1888 Kodak Camera No. 1 are 2½″ in diameter; those from the 1889 Kodak No. 2 are 3½″ in diameter, often mounted on a thick card.)

It was in the advertising for these early Kodak cameras that the famous phrase "You press the button—we do the rest!" first appeared.

8. *Kodak Camera No. 1. A print from Eastman's original stripping film negative. American. 1888. Early Kodak images were circular and are now collector's items.*

9. *Kodak Camera No. 1. Cyanotype print from Eastman's new roll film. American. 1896. The camera was loaded at the factory with film sufficient for 100 circular exposures and was returned to the factory each time for developing and printing.*

10. *Kodak Camera No. 2. Mounted factory print of the Capitol, Richmond, Virginia. American. 1894. The No. 2 camera was introduced in 1889 and took larger (3½″) images than the No. 1.*

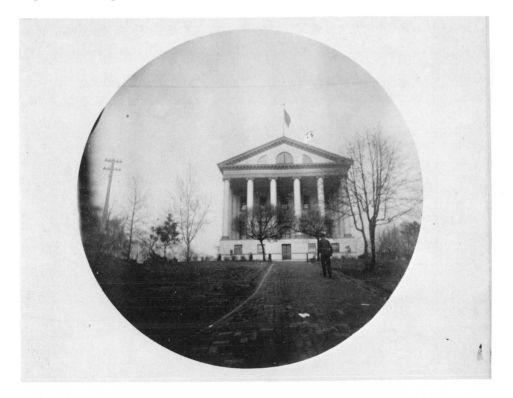

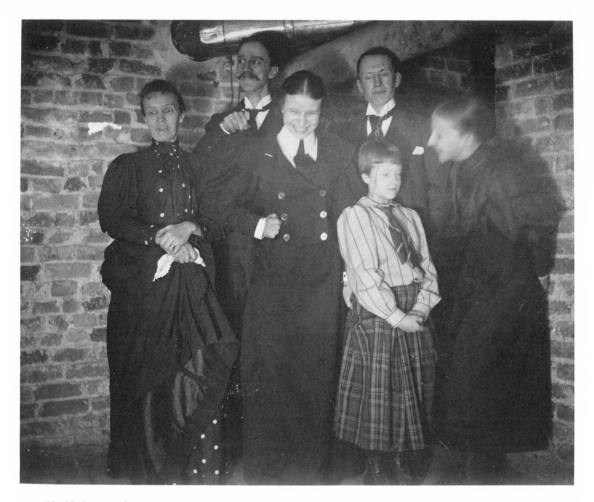

11. *Flashlight snapshot.*
Albumen print. Amer-
ican. 1894. Magnesium
flash equipment opened
up new possibilities for
the amateur. Now snap-
shots could be taken
indoors.

The universality of photography was suddenly fact. "A collection of these pictures," George Eastman promised his potential customers, "may be made to furnish a pictorial history of life as it is lived by the owner, that will grow more valuable every day that passes." It was a salesman talking, but he spoke like a prophet, and a persuasive prophet at that. "We furnish anybody," he added, "man or woman or child, who has sufficient intelligence to point a box straight and press a button . . . with an instrument which altogether removes from the practice of photography the necessity for exceptional facilities or, in fact, any special knowledge of the art."

From that point, Kodak, in quite an inspired way, kept pace with

the amateur photographer's needs and aspirations. It produced the first transparent roll film, folding cameras, printing-out papers, pocket cameras, and, in 1900, the famous and long-lived range of Brownie cameras, the first of which sold for a dollar and used film costing only fifteen cents a roll. By 1905 there were an estimated ten million amateur photographers in the United States and another four million in Britain. Today, thousands of millions of snapshots are taken annually. The Box Brownie gave the world a new eye; the cheap roll film gave it folk art in gelatin.

12. *Snapshot. American. c.1940. The snapper snapped. By the end of the 1930s, no party, picnic, or celebration was complete without an amateur snap shooter there to record it.*

The popularity of the home camera also had a lot to do with the emerging do-it-yourself spirit of twentieth-century man. Producing acceptable photographs was an unexpectedly easy achievement and certainly less demanding of skill and talent than watercolor painting or playing the piano. And, as dozens of examples in this book clearly show, neither ignorance nor incompetence necessarily stood in the way of extraordinary results. Nothing quite like it had ever been placed in the hands of the ordinary person before, and not surprisingly, as a pastime and as a hobby, the craze for photography swept most of the world. Unlike most crazes its popularity did not fade.

The cost factor, too, changed the nature of popular photography. In the glass-plate era, every exposure required patience, trouble, and considerable expense. Thus most photographs before Kodak universality tended to be of "significant" subjects—imposing views, important people and events, serious portraits. Few could afford to risk a shot of the mundane or ephemeral. But with cheap, popular cameras came a new spirit of photo adventure, a spirit of "let's take a picture, it might come out!"

If amateur photography needed a stimulus by the mid-1930s, which I doubt, then the introduction of color film would have supplied it. Until the marketing of Kodachrome in 1935, color processes were uncertain and expensive. Those who pined for color achieved it with the aid of a brush and a photo tinting outfit. Although the use of color

13. *Snapshot. American. 1940s. This torn, stained, and faded keepsake from a soldier's wallet typifies the memento status of the snapshot during World War II. The emotional needs of war gave a great boost to family photography.*

14. Hand-colored snapshot. American. c.1938. Before color film became universally available after World War II, monochrome prints were tinted by hand in the quest for more life-like images.

film was checked by World War II, the postwar period ushered in a chromatic era in snapshot history, climaxing in the 1970s when almost every snapshot was taken in color. Nowadays it is getting difficult to find a processor who will handle monochrome film.

Another milestone in the development of the snapshot was the invention, in 1947, of the Polaroid "instant" camera by Edwin Land. At first, Polaroid images were in black and white and represented only a technological advance. But with the introduction of color, Polaroid photography added a romantic dimension to the snapshot. Although the dyes in the instant film's developing envelope were approximately true, reality was undeniably enhanced by the richness of Polaroid's unique color chemistry. Particularly with the three-inch-square images of the SX-70, which are shot out already glazed and matted, users were surprised to find that occasionally they had produced something akin to a Holbein miniature, glowing and sensual.

It seems likely that recent developments in photography may subtly change the amateur's perception of how and why he makes his images.

15. *Color snapshot. English. c.1950. The chromatic precision of early color developing left much to be desired. But film and processes improved and, by the 1970s, nine out of ten snapshots were in color.*

16. *Polaroid Polacolor print. American. 1963. It took fifteen years after the introduction of monochrome Polaroid prints to perfect and market the color equivalent. Now, instant color photography is a fact of life.*

The instant camera, for example, offers an *immediate* two-dimensional record, existing side by side with the subject, of what is seen by the eye and mind. He can check the record against the subject at the time, not against his memory when the film is developed and the prints are returned, days later.

The almost indecent ease with which snapshots can now be taken; the uniformity of acceptable results, when thirty-six prints are regularly returned from thirty-six exposures for just a few dollars; the immediate gratification of instant images—such factors, I'm certain, must tend to lessen the traditional keepsake cachet of the family snapshot.

As you read this, the amateur is in possession of some impressively sophisticated optical hardware. Exposure and focusing are automatic. Motor drives have eliminated the "snap" and "click," now replaced by a continuous "ker-zap, ker-zap, ker-zap." The practical 3-D camera and the video recording of single images, to be called up on a TV screen, threaten to trash a century of photographic tradition. An interesting question: Will these novel and intangible images further change the essential nature of the snapshot?

Regardless of the answer, snapshots in one form or another are certain to remain an important element of popular culture. As Susan Sontag wryly concludes, "Needing to have reality confirmed and expe-

rience enhanced by photographs is an aesthetic consumerism to which everyone is now addicted. Industrial societies turn their citizens into image-junkies; it is the most irresistible form of mental pollution."

Dating of Photographic Processes	
Daguerreotypes	1839–c.1860
Calotypes	1841–c.1860
Cyanotypes	1842–c.1910
Salt prints	1850–c.1860
Albumen prints	1850–c.1895
Ambrotypes	1852–1865
Stereographs	1850s—
Tintypes	1856–1940
Emulsion prints	1887—
Kodak Circular prints	1888–c.1895
Kodak Pocket prints 2¼″ × 3¼″	1898—
Colorsnaps; Colorol prints	1929—
Kodak Verichrome	1931—
Kodachrome	1935—
Kodak Minicolor prints	1941—
Kodacolor	1942—
Ansco Color	1942–1955
Ektachrome	1946—
Gevacolor	1947–1964
Ferraniacolor	1947–1969
Ilford Color	1948–1960
Polaroid (monochrome)	1948—
Fujicolor	1948—
Dynacolor	1949–1959
Ektacolor	1955—
Dynachrome	1959–1970
Ilfachrome	1960–1962
Kodachrome II	1961—
Ilfochrome	1962—1965
SX-70	1962—
Polacolor	1963—
Kodak PR-10 Instant	1976—
Nimslo 3-D	1982—

2

Folk Art in Gelatin

The Snapshot's "Golden Age"

THE COUNTRY HOUSES of the English aristocracy provided first the birthplace and subsequently the nursery for the emerging pastime of photography. The inhabitants of these houses were, after all, among the fortunate few with the time, the money, and the facilities for the demanding techniques of early photographic art. So it is in the trove of albums and scrapbooks recently unearthed in the libraries and collections of stately homes that we find the forerunners of today's snapshots—photographs taken for amusement rather than profit and with an exploratory enthusiasm rather than an urge to create art.

And while the quickly established commercial branch of photography petrified hundreds of thousands of faces and groups posed before stylized studio backdrops, it was the amateur, in those early years, who recorded the environment, fashions, interests, and especially the family life of the mid-Victorian period—at least that of the well-to-do. Then, at the turn of the century, followed the more humble owners of those millions of cheap cameras, without pretensions and aspirations other than the desire to snap a picture and the hope for a viewable result.

With hindsight, we now realize that the truest of all photographic images taken over the past century have come from this often ridiculed group. Commenting recently on a pictorial biography of

H. G. Wells, his son, Anthony West, remarked that it was a pity that all the photographs of the novelist reproduced in the book were posed studio portraits, which in his opinion "mislead absolutely." He went on to say, "It is only when the camera catches him unawares, or momentarily absorbed by his company or by what he is doing, that it gives one anything worth having in the way of insight." Such was the deceptive nature of the posed photograph that a son could hardly recognize his father! It seems that our overall view of life during the last hundred years owes much more to the snapshot than we give it credit for. Snapshots alone caught mankind with its pants down, spontaneously and often inelegantly, but always faithfully.

Why, then, has this staggering truth not burst upon the world before now? One answer is that nobody bothered much to examine family photographs. The family snapshot, because it was so familiar, so commonplace, carried the implication that all amateur images were banal and worthless outside their intended milieu. Consequently it is hardly surprising that we were late in coming to appreciate the snapshot for what it uniquely has to offer.

So this much maligned form—*Punch* was lampooning amateur photographers as long ago as 1850—has generally been consigned to the detritus of our lives when its usefulness expired. Even now, among dealers in memorabilia and at antique and ephemera fairs, one may find any number of Victorian photographs of the studio and scenic variety, but search in vain for the plain snapshots taken by our parents and grandparents. Billions of these potentially valuable folk documents have undoubtedly been lost or forgotten.

Which is a pity, because I believe there was a Golden Age of the snapshot, and I fix it approximately between 1910 and 1950. This corresponds with the period when cheap cameras were in universal use for the simple purpose of recording private lives.

The turn of the century boom in amateur photography also coincided with the emergence of the family as the emotional and material core of contemporary life. Tremendous economic and cultural pressures were exerted on every adult to get married, to acquire a home, and to begin a family, and the snapshot played a vital role in idealizing the phenomenon. The comforts enshrined in the family album rationalized human purpose; and one's daily grind, mortgages, debts, and troublesome in-laws all became more bearable when balanced against the happy occasions and the achievements recorded in one's snapshots (17).

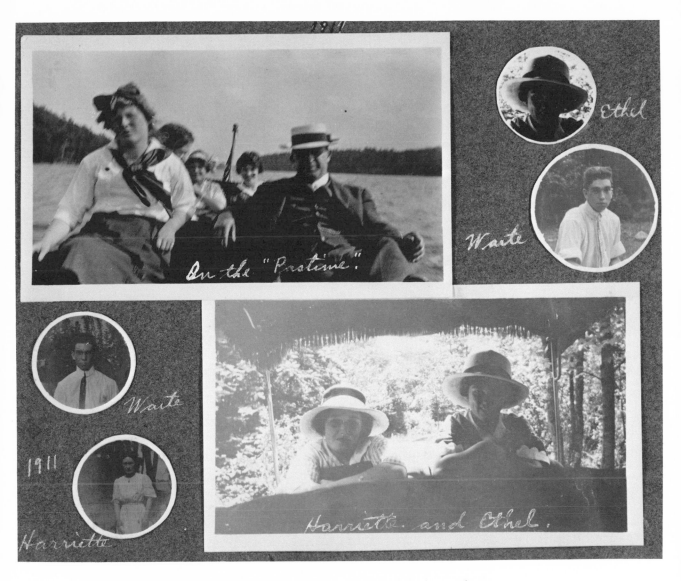

On the "Pastime."

Ethel

Waite

Waite

1911

Harriette

Harriette. and Ethel.

17. Page from a family album. American. 1911. Typical of the love and care lavished on snapshot mementoes in the "Golden Age." The album replaced the family Bible of the nineteenth century and became, as someone once remarked, "the poor man's coat of arms."

18. *Oleograph postcard with snapshot. American. c.1910. The arrival of cheap cameras and film, and the ease with which acceptable snapshots could be made, transformed photography into a kind of "folk art in gelatin."*

This was also the period when the snapshot was the most available form of original "art" and therefore the most democratic (18). Unfettered and uninfluenced by critics and historians, the Golden Age snapshot represented a vital source of imagery for ordinary people, from which they experienced a range of satisfying responses. And snapshots were *relevant* to ordinary people on an almost daily basis.

If anybody can claim to be the modern apostle of the family snapshot it could be the American writer Michael Lesy, author of *Wisconsin Death Trip* (Random House, 1973) and *Time Frames: The Meaning of Family Pictures* (Pantheon Books, 1980). Lesy prepared himself for the role of snapshot evangelist by looking at several hundred thousand snaps, most of them quality-control rejects from Los Angeles photofinishing firms.

Lesy eventually found himself submerged and confused in this swirling sea of anonymous images: "Sometimes I think it changed my personality," he wrote, "and sometimes I wonder if it didn't damage my brain . . . over a period of time you begin to lose track of the idea of people's individuality . . . you begin to think about genotypes . . . and start thinking about pictures as symbols. . . ."

The experience led Lesy back to restoring the snapshot to its narrative and iconographic context: to finding out who the people were in his pictures; what they were doing when the photo was taken; and why it was taken. As a result, his interest polarized away from snapshots as

images, and his explorations have been almost exclusively concerned with the lives of the people in them. Still, he has contributed some reflective concepts to snapshot scholarship. A good example is his description of what family snapshots might mean to children: ". . . they reveal to children that they have been standing in one place—where four rivers of time converge: their own, private, secret time ("Who is that baby? Is that me?"); their family's time ("Is that when we lived in St. Louis?"); their country's time ("Is that when Daddy was in the army?"); and mythic time, the common poetry of the human family ("Is that when you and Daddy were in love? I mean, before you got married and had babies?")."

To the objective outsider, anonymous family snapshots fall into several quite distinct groups. Perhaps the most fundamental of these concerns a family's need for some expression of its material assets. Of an average family's possessions, the home, above all, most impressively symbolizes achievement. Its style, size, and state of repair all offer evidence of the family's relative prosperity. No matter whether the home is grand (19), homely (20), or humble (21), we are meant to see that the family is secure, sheltered, respectable, and doing well, thank you.

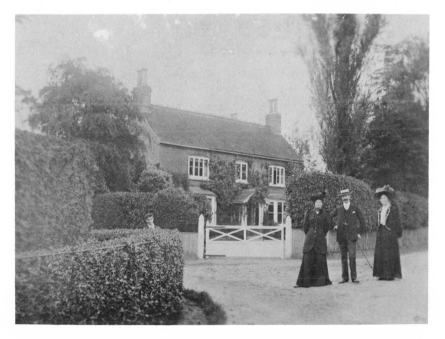

19. Toned emulsion print. English. c. 1900. The camera enabled middle-class families to imitate eighteenth-century paintings of the English gentry posed in front of their estates.

20. *Snapshot. English. 1930. A somewhat more homely estate, but still an expression of the family's most prestigious possession—a house.*

21. *Snapshot. English. 1910. No matter how prosaic or humble, or whether owned or rented, the home as backdrop represented status.*

Such snapshots of the family at home can be astonishingly comprehensive. The family group posing on their front porch (22) also includes the family dog, even favorite plants. Yet another group (23), while understating its domicile—a simple terrace house—focuses on the family itself in extraordinary detail, reminiscent of eighteenth-century English paintings of the gentry and their families, with their grand house seen distantly as a backdrop.

To us, the majority of houses depicted in snapshots are extremely prosaic, but to their occupants they are an obvious source of pride; and if we ever wanted a visual definition of a home, as distinct from a

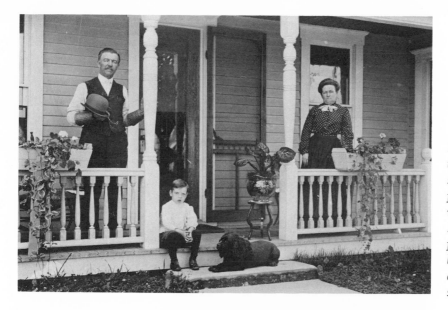

22. Snapshot. American. c. 1905. A superbly orchestrated family facade intended to reassure and impress. Even the family dog and favorite houseplants have been included in this comprehensive visual statement.

23. Snapshot. English. 1910. Although the house itself has been understated, this portrait of an Edwardian family is so replete with detail (exemplary dress and grooming, expressions, and body language) we easily get the message: they're respectable, secure, and successful.

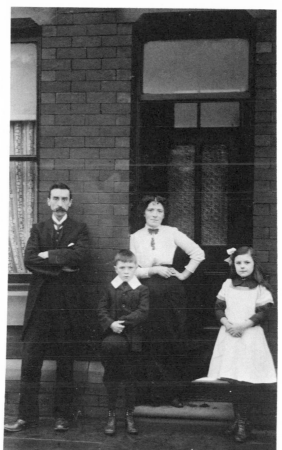

house, it will be found in this group of snapshots. The house in Plate 24 is no different from two or three million of its kind in Britain, until the group of children standing in front gives it its individuality as a home. To them, 36 Kingswood Crescent was always a special place, and so it is for us as viewers, almost a century later.

24. *Snapshot. Sepia-toned print. English. c.1905. Although in Britian there are millions of houses similar in size, style, and age to this one, the children posed so charmingly in front give it the individuality of a home.*

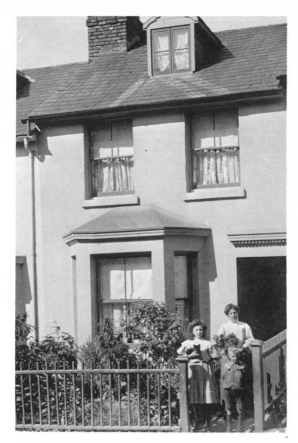

25. *Snapshot. Toned print. English. c. 1915.*
Humble family portraits like this one—the mother
touchingly holds a bouquet and the daughter cradles
the family cat—have the ingenuousness of a naive
painting.

26. *Snapshot. Albumen print. American. c. 1900.*
Occasionally a family house portrait transcends its
modest purpose; here, the strongly patterned facade,
the geometric divisions, and the lone figure, form a
quite striking composition. Note the milk jug by the
open door.

Toward the end of the snapshot's Golden Age one can detect some
slippage in the preeminence of the house as a family's material cor-
nerstone. Perhaps today we expect viewers of our snapshots to make
the assumption that we have a house; or it could be that a family group
posed by an apartment doorway simply fails to convey the same weight
of symbolism. Thus gardens and swimming pools are increasingly sub-
stituted as prosperity props, and universal flash now enables a family to
flaunt its inventory of furniture and taste in decor. On a less happy
note, the growing absence of the home in contemporary snapshots

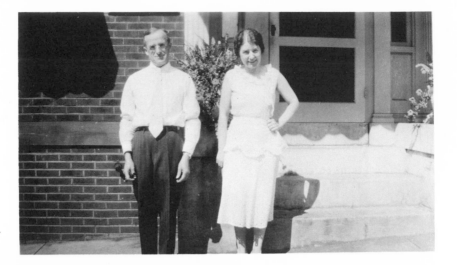

27. Snapshot. American. 1940s. More often, however, families posed in front of their houses fall just short of parody, emphasizing our commonplace existence.

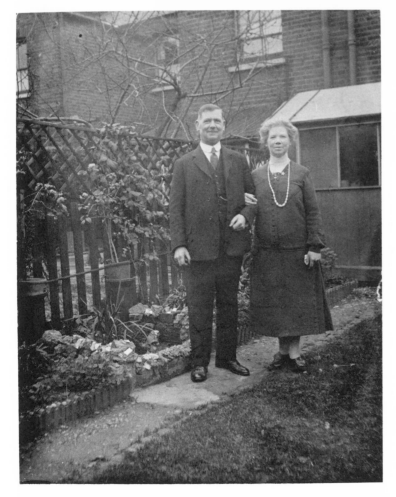

28. Snapshot. Toned print. English. c. 1920. A couple pose proudly in their plot. Backyards and gardens are also used extensively to confirm ownership of a home.

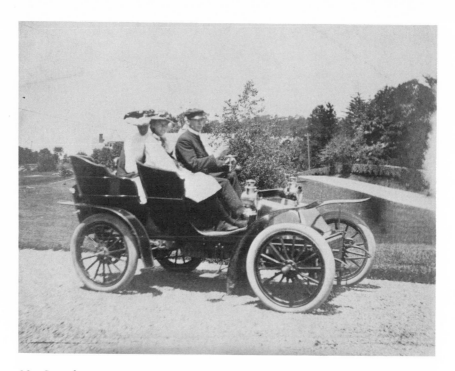

29. *Snapshot. American. c.1900. From the turn of the century the automobile featured prominently in the family album. Next to a house it was the most important tribal possession.*

could reflect a fact of modern life: the loosening and abandonment of the traditional family values that are so evident in the snapshots from the Golden Age.

Next in line on the family's balance sheet of resources was, from early in this century, the automobile. Possession of a car often implied not only that the family could afford one (or afford the monthly payments), but that it also had the time and money to use it for trips and vacations and had the skill to drive it. It soon becomes an urban icon, and not only because of its convenience. Look, for example, at the lady posed by the 1930 sedan (30); the auto gets pride of place while the woman is merely a decoration.

You'll have a lot of fun examining family car photos taken over the years. In one type of shot everyone gets into the act (31), while in another, ostentation is discarded in favor of nonchalance (32). But in

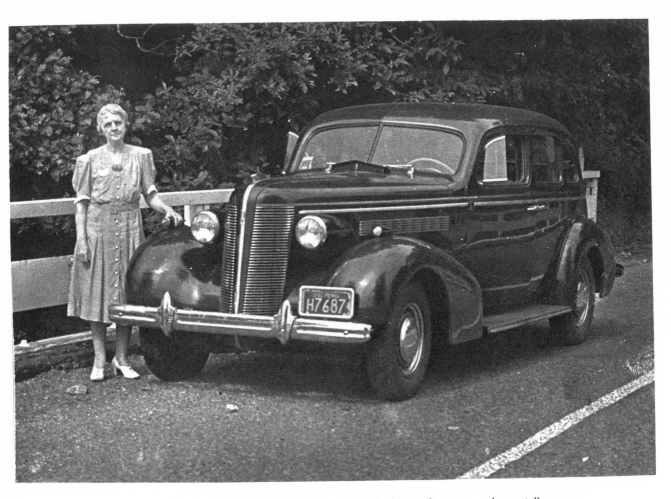

30. *Snapshot. American. c. 1936. Until recently a car, and especially a new car, was a conspicuous status symbol for most families. In keeping with its status, the car occupied the lion's share of space in this snapshot.*

all cases the point is clearly made: the family owns a car. Today, however, the ubiquitous automobile is hardly the status symbol it once was, and contemporary snapshots require a wide-angle shot of a garage housing two cars and a speedboat to achieve the same effect.

The status inherent in possessions, as seen in snapshots, does not, of course, end with houses and cars. Family pets have a certain status, as do power lawn mowers, vacation homes, garden furniture, and the

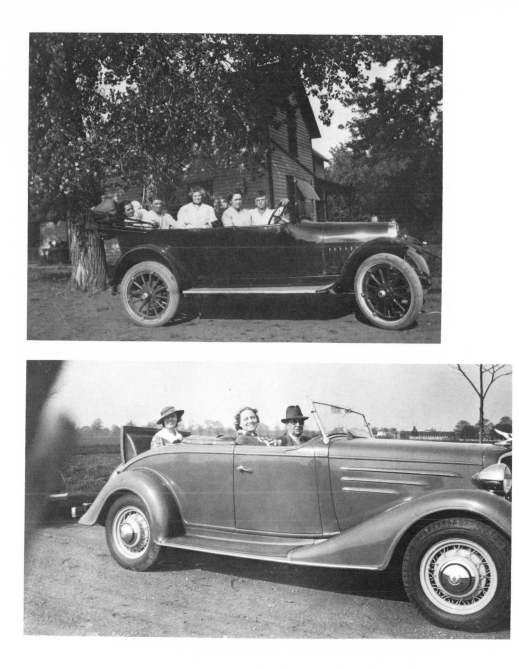

31. *Snapshots. American. 1920s and c.1940. Typical family car snapshots, twenty years apart. The essential elements—side view with driver and passengers—remain constant.*

32. *Snapshots. American. 1920s. Another type of car shot where ostentation is replaced by nonchalance. But pride of ownership is still evident.*

like. But possessions finally run out, and then a family typically resorts to the achievements of its members, giving rise to another group of snapshots I call "Pride in Achievement." Trophies may be won and displayed in the living room, but it was also apparently considered important to record them with snapshots, along with the achiever.

33. *Snapshot. English.*
c.1920. In the absence
of a car, the motorcycle
was both a novelty and a
favorite prop.

34. *Snapshot. English. c.1910. For most families, a dearth of genuine accom-*
plishment meant displaying its possessions to express the achievement the world
expected of it. But real achievement was recorded with jealous care; the camera is
focused on the model airplane, rather than the boy.

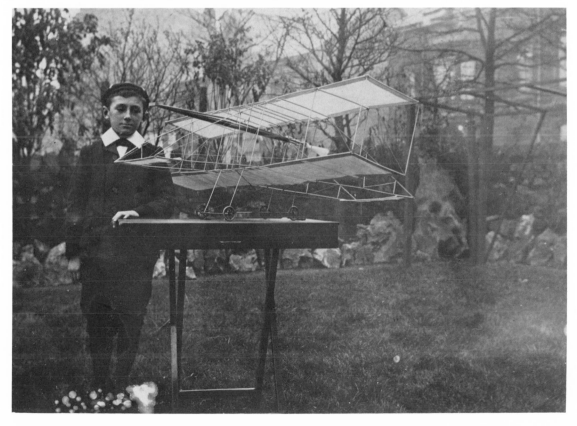

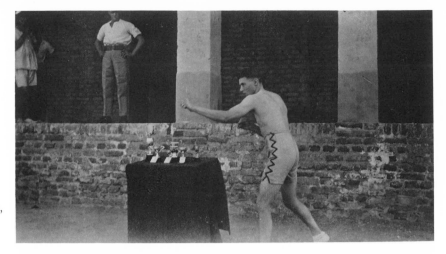

35. *Snapshot. India. c.1925. A typical achievement pose. Today's graduation portrait, with cap, gown, and diploma, is in the same genre.*

Graduation photographs obviously fall into this group, representing intellectual achievement, side by side with all those hunting and fishing snapshots, expressing something more primitive. Snapshots of people holding fish (36) have a particular appeal for me, representing as they do human achievement in its most folksy and basic form; while shots that include not only the game but also the car, implying achievement *and* possession, are surely the epitome of the family snapshot.

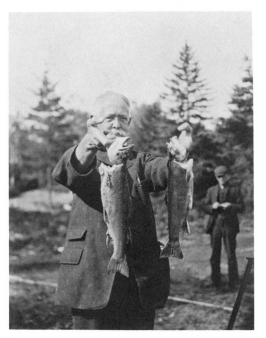

36. *Snapshots. American. 1930s. The Catch. Hunters and anglers seem equally eager to stalk the camera, and snapshots recording such achievements became common album fodder.*

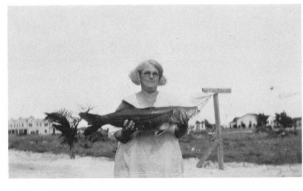

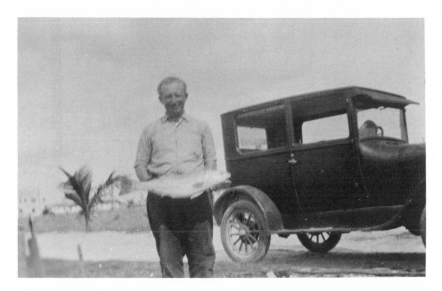

37. *Snapshot. American c. 1930. This shot combines achievement (the fish) and possessions (the car).*

38. *Snapshot. American. c. 1935. The epitome of the family snapshot: the man as hunter and parent, the achievement in the catch, and the family car.*

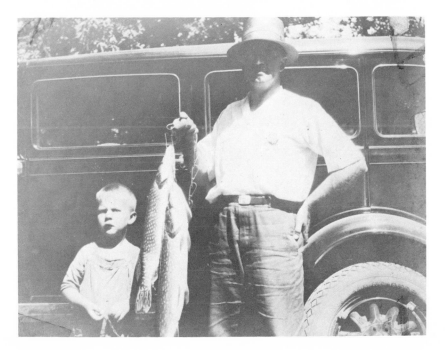

Look as intently as you may at snapshots from the Golden Age and you will see no grandeur or great events, no horror or hatred, no sex or sadness. What you will see is what you were meant to see: visual snippets of lives that ran their course in a milieu of apparent satisfaction and happiness. These snapshots, of parties and picnics and vacations, form easily the largest grouping among family photographs, vernacular records of people at play. And the group is most aptly illustrated, I think, by snapshots taken by the sea.

For at least a century, until the invention of the package holiday, generations of British families liked to be beside the seaside. Europeans and Americans shared this fondness for the sea, but for some reason not the lemming-like rush for the coast that became a summer ritual in the British Isles.

The snapshot played, I'm sure, a hitherto unrecognized role in the creation of seaside mythology. When the sun shone—as of course it

39. Snapshot. Albumen print. American. c.1895. The seaside brought out the playfulness in people. But are the capering couple here disguising their embarrassment in being caught in that unlovely and impractical garment, the Victorian bathing suit?

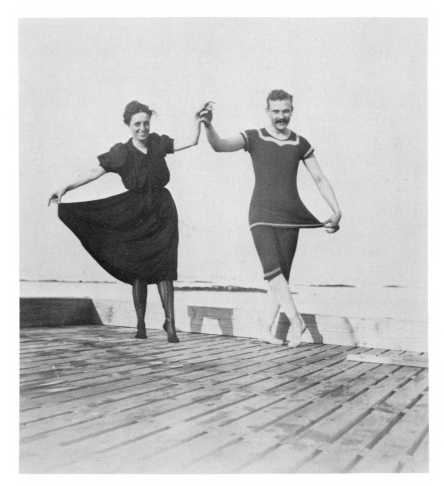

always did in our childhood memories of hot sand, warm seas, sun-burn, lotion, and ice cream—it unleashed the combined recording power of millions of Kodaks. But when clouds gathered, when a sharp wind whipped up waves and the sea turned gray, the shutters were mostly silent; very few people take snapshots in the rain.

As adults, we're bound to wonder about that unsullied weather of our childhood and those joyful weeks on sun-baked sands. It certainly wasn't a dream, for the proof is before us, in the family album. Momentarily blaming polar ice cap activity, we then examine the photographs with more care to discover, in fact, sufficient contradictions to challenge our memory and even shatter the myth. We find, for example, ample evidence that sea bathing was accompanied, more often than not, by considerable discomfort. Before 1920, bathing garments were voluminous (39). Who today would go swimming while fully clothed, complete with stockings and boots? And but for his pail and

40. Toned print. American. 1896. A forerunner of millions of its kind, perhaps to prove that the bathing suits really did get wet.

41. *Snapshot. German. c.1925. A disarming seaside snapshot, capturing the juvenescence the sea seems to generate in otherwise sober adults.*

shovel, the little boy (42) and his abundantly overdressed mother could be going anywhere but to the beach!

The truth about many seaside resorts, and those in Britain in particular, was that not a lot of bathing actually took place. I've looked at hundreds of seaside snapshots and have rarely seen anybody in the water. It seems that most people did not go down to the sea to bathe, and many snapshots depict bemused folks, dressed against the chill breezes, who appear to be at a loss for something further to do than sit on the sand until it was time to return home. And only in a few places could you find a few square yards of sand anyway; the typical English beach consisted of an area of pebbles and shingle, divided at intervals by groynes, traversed by donkeys, bounded by an implacably cold sea on the one hand, a voracious amusement park on the other, and fleshed by gales that blew direct from Greenland. Our fond memories

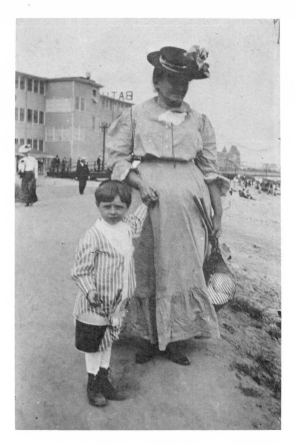

42. *Sepia print. America. 1903. Childhood memories of seaside holidays are irrevocably golden; forgotten are the discomforts, bad weather, and stern parents.*

43. *Snapshot. English. 1930s. Most British seaside snapshots contradict our fondly held memories of crowds playing on the sands and splashing in the water.*

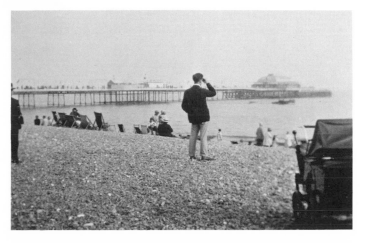

44. Snapshot. English. 1920s. Many snapshots reveal the cruel evidence that those magic beaches of our childhood were often places of considerable discomfort.

notwithstanding, that is the picture one can extract from snapshots (44).

The reason our beliefs persist is that of course snapshots *do* exist of those occasions when the sun shone hotly and the sea received bodies into its bosom without turning them blue (45). Such images clearly have terrific power, and we retain them with a fanaticism that invites some serious study. People learned to adapt to the seaside's exigencies. Promenading in one's furs was as good a way as any of gulping in some ozone while keeping warm. The deck chair was invented, which was as much a device for avoiding the cold wind as for catching the sun

45. *Snapshot. English. 1920s. Obviously there were days when it was possible to swim, and on those days the camera was hyperactive. But note, in the lower photograph, that adult commitment to the sea was often equivocal.*

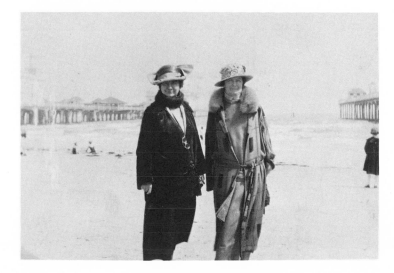

46. *Snapshot. American. c.1920. People soon learned to cope with the vicissitudes of the seaside. Promenading in full regalia was one popular pastime.*

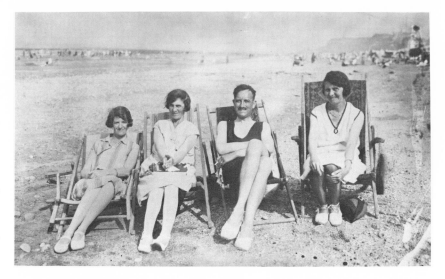

47. *Snapshot. English. 1920s. The invention of the deck chair overcame the discomfort of shingle and pebbles, a feature of most English beaches.*

(47, 48). But none of this, apparently, in any way discouraged each summer's millions of sea-bound holiday makers. Just look (49) at the gleeful expectation on the faces of the family just arrived by train at a seaside station! On the one fine day during their stay they will take their snapshots and so perpetuate the seaside holiday myth.

Interestingly, the seaside was the breeding ground for what can only be called the commercial snapshot. The need for some photographic evidence of one's presence there was so powerful that small armies of photographers made fortunes each summer supplying snapshots to cameraless visitors.

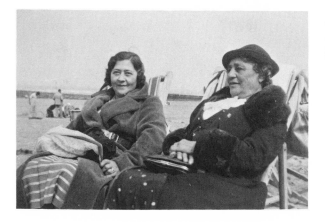

48. *Snapshot. English. 1930s. The deck chair was also as much a device for avoiding the chilly breezes as for catching the sun.*

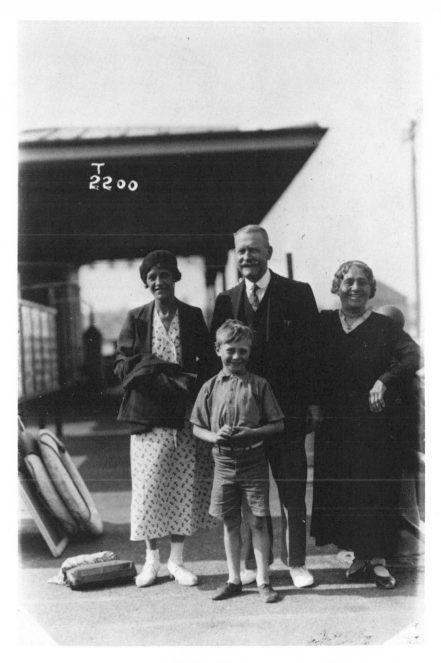

49. *Commercial snapshot. English. c.1930. No banal seaside souvenir this, but a picture that captures all the exhilaration of arrival and the anticipation of happy times ahead.*

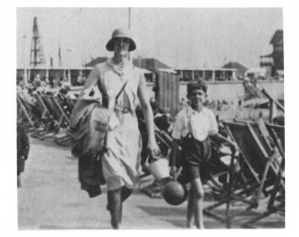

50. *"Walking snap."
English. c.1930. Fran-
chised cameramen at the
various watering places
specialized in ephemeral
candids like this. Millions
were taken and sold
every summer.*

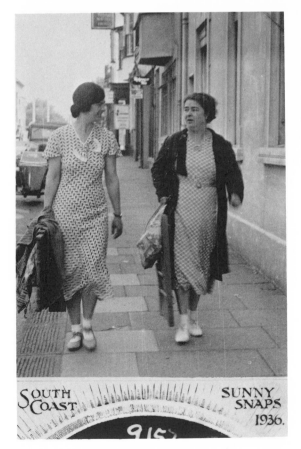

51. *"Sunny snaps."
English. 1936. Com-
mercial snapshots were
of the most basic kind,
and speed was essential,
whatever the result. The
photographer would take
the picture, then attempt
to get payment for it.*

If you look at a large number of family snapshots in a chronological sense you'll detect a sort of stratification. When cameras were skill-intensive and film relatively expensive, picture-taking was much more of an orchestrated event than it is today. The picture had to be "worth taking," whereas today amateurs will casually expose their film at the inconsequential knowing that the aim, speed, and exposure will be about right and only sheer bad luck will prevent them from getting a viewable shot. Over fifty years the attitude of the amateur has doubtless changed, but how is this change reflected in snapshots?

Well, for one thing, today's amateur captures more candid moments, more laughs, and more groups of people in interaction. The pictures are perhaps less thoughtful, less composed, but are no less attractive for that. Because there is less accent on posing, we do not now see so many "Dad with his new car" pictures; "pride pictures" (people in uniform, fancy dress, newly bought clothes); trick shots (distant figure "standing" on close-up hand); or dynasty pictures (assemblies of several generations of a family).

And now that the snapshot has irreversibly entered the electronic age, many more changes are imminent.

Compact cameras with microchips controlling automatic focusing and exposure now dominate amateur photography. Flash units, too, are computer controlled. A new camera that gives verbal commands to help the user avoid common mistakes (*Load film! Check distance! Too dark, use flash!*) has just made its debut. But the most far-reaching new development, so far as the amateur is concerned, is the revolutionary new generation of cheap disc cameras not much bigger than cigarette packages. You point them, shoot, and within a second a tiny motor advances the film for the next shot, giving the user the equivalent of the vastly more expensive motor drive attachments.

The "point and shoot" amateur now holds in his unsteady hands wonder toys that would have seemed inconceivable less than a decade ago, and with them the ability to shoot almost anything, in an instant, with "laser-sharp pictures from thirty-three inches to infinity" according to one manufacturer's claim, in virtually any light conditions. And with 1000ASA color film now in the stores, this is considered the beginning of a new photographic era, not the close.

One would imagine that this spectacular technological leap will have some effect on the resultant product, and indeed it already has. Gone forever are some of the more bizarre aberrations of the past. And

52. *Snapshot.*
Kodachrome print.
American. 1981. The
new generation of faster,
sharper, and brighter
color films combined
with wide-angled cam-
eras has resulted in
pictures crowded with
detail. This example
displays a surprising
collection of objects; for-
tunately its accidental
radiating composition
draws the eye into the
picture and satisfactorily
unifies all the elements.

amateur photographs are now generally more in tune with real life—casual, natural images that are sharper, brighter, closer, more colorful, and even more interesting.

On the other hand the new cameras have introduced an entertaining range of curiosa and quirks. The amateur, it seems, is not using his high-tech toy to solve the traditional problems associated with making good pictures, but rather to assay fresh challenges undreamed of in the box camera era.

The modern camera, with its hungry, wide-angle lens, positively thirsts after detail, and snapshots of the eighties are havens for the irrelevant; too often the nonessentials turn out to be more captivating than the intended subject. The contemporary camera's low light capacity encourages indoor shooting, with the result that the former, broader snapshot landscape has shrunk to the confines of the couch and the living room carpet. According to one bulk film processor, half the snapshots these days are of individuals and groups at a party or

some festive, social, or family occasion, usually indoors. And with film and processing costs now down to a few cents a picture, amateurs are tempted to shoot literally anything—steaks on a barbecue, a new bedspread, grandpa's bald head—you name it, the amateur will shoot it. Banality, it appears, will always figure largely in the world of the snapshot.

Other changes, too, can be tracked back to the new technology. Those of you who are middle-aged may remember the rare occasions as a child when you were allowed to handle a camera. The four-dollar instrument was handed to you with fear and trembling and you were admonished "not to waste the film." Today, the fiercely competitive film and processing industry has changed all that and it is not uncommon for children to take snapshots from a very early age. One is prompted to wonder if the snapshots taken by children differ consistently in any way from those taken by adults: an intriguing area for further inquiry.

53. Snapshot. Agfachrome print. English. 1982. A generation ago children were rarely permitted to handle even simple cameras for fear they "would waste film." New foolproof equipment and cheap film have changed all that; children today are encouraged to take snapshots.

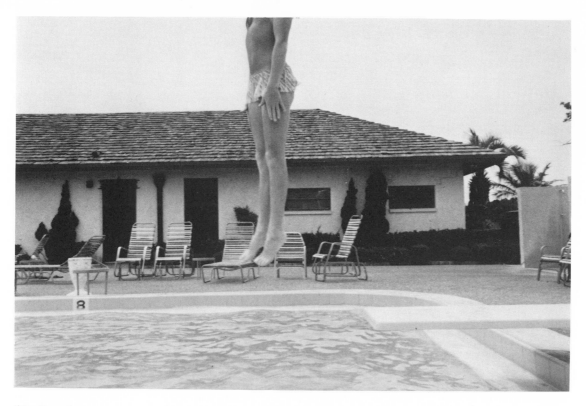

54. *Snapshot.*
Kodachrome print.
American. 1980. Any
owner of a camera
equipped with motor
drive will recognize this
shot. In amateur hands
two or three are guaran-
teed in every roll, much
to the delight of film
manufacturers and
processors.

Of all the new "improvements," however, the little drive motors probably contribute more to the amateur's undoing than any other technical advance. With Mack Sennett's dictum in mind —"It's gotta move!"—today's snapshot taker is mad for motion. A diver springs from a diving board! Zzap! Zzap! Zzap! Three frames flash by as he heads for the water. Unfortunately, in too many cases, every shot manages somehow to avoid the diver, the final frame recording perfectly a frozen, almost abstract splash (55).

Other new developments in image recording seem unlikely to guarantee better snapshots. The revolutionary quadra-lens Nimslo 3-D camera actually turns the clock back; the user is instructed to allow six feet between camera and subject, which was pretty much what the box camera owner was requested to do half a century ago. Nevertheless it is too early to predict just how the extra dimension of 3-D will alter our snap-shooting habits. As the manufacturers say, there's a whole new world of depth out there.

Then, of course, there is pure electronic imagery—both the kind that records still pictures to be "called up" and displayed on a TV screen, and the electronic version of the movie camera, the cassette video recorder. What does our average shutterbug record? "The thing they always start with," according to a British video consultant, "is a back shot of themselves. They want to see how they really look from behind. To see if their bottoms are really that big." No significant aesthetic breakthrough here.

But in fact there *has* been a quiet revolution of sorts, and it has altered the nature of a great many snapshots we take. The revolution has nothing to do with the latest high-tech gadgetry just reviewed but is rather the result of the mechanization of photo processing and that technical wonder of a generation ago, the Polaroid or instant snapshot.

55. Snapshot sequence. Kodachrome prints. 1982. With a motor drive attached, the "point and shoot" amateur has come close to losing control of his camera. With the promise of capturing more he invariably achieves less—if you don't include bizarre effects.

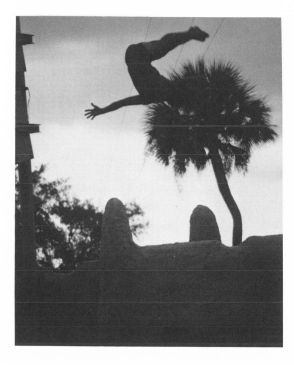 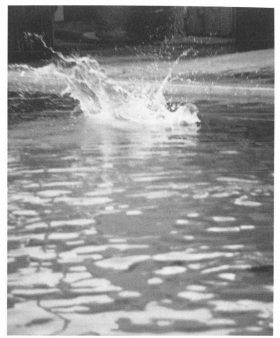

There was a time when your roll of film, once deposited at the local druggist or film supply store, would be developed and manually printed by some dear old God-fearing lady in the back room who, in a small community, might even know you personally; or, worse, by a chortling youth eager for some indelicate material with which to entertain his voyeuristic friends. Obviously the risqué was too risky. Most processors, in any case, had strict rules about this: For years the Eastman Kodak Co. would not return prints or slides of nudes to avoid running afoul of U.S. postal laws.

These days, exposed film is collected to be processed at a central location, or received by mail; it is developed and printed by mechanized and computerized equipment, ostensibly without being touched by the human hand or seen by the human eye. This darkroom anonymity has understandably emboldened the amateur. In a recent newspaper interview, an operator who had worked at a New England photo-processing plant for thirty-six years said that she saw "a big increase" in home-based pornography while sampling for color accuracy the six thousand snapshots an hour output of her machine.

The manager of a large British photo laboratory specializing in mail order processing confirmed this statement. While being coy about how "anonymous" mechanized processing really was, he did admit it was difficult to avoid noticing the quantity of "saucy" snapshots passing through. "We mail back a quarter of a million prints a week," he added, "and the finished prints are packed in the envelopes by hand. Our people are constantly surprised by some of the things they see. Really way-out shots are still the topic of the coffee break." He concluded warily, "It's a rule here, though, that anyone making copies of customers' snaps for themselves is instantly dismissed."

In recent years, it seems, the snapshot has lost some of its innocence.

There is, clearly, in many people, an overwhelming impulse to record their genitalia on film. According to another processing manager, "We get a lot of sneaky snapshots taken with telephoto lenses, but mostly it's the husband photographing his wife or girl friend and vice versa, in all the positions imaginable. And if a man's wife has nice breasts, it's ten to one he'll want to photograph them." There is no thought of censoring by the processors, however. "Everything we get goes through the soup and gets returned to the customer," the manager added.

The ultimate private snapshot is, of course, the Polaroid or instant

photograph, a truly unique image which need be seen only by the consenting parties. While instant camera systems are undoubtedly used—as the manufacturers like to demonstrate in television commercials—to take charming family snapshots, many users realize eventually that conventional cameras can do the same job better and cheaper. This could be one reason why the owner of an instant camera is tempted to use it for a more specialized purpose, that of recording erotic activities. But (and because of their very nature I confess to having seen few examples) it appears that amateur attempts at erotic photography have failed to rise above the general standards of overt snapology. Inspired by the *Playboy* centerfold or the erotic autoportraiture of the Greek-born American photographer Lucas Samaras, the results invariably border on the ludicrous. As a processing operative observed, "Nudity is everywhere, so why be surprised if people try to copy what they see in magazines? The trouble is they all think they're beautiful, which they're not. Once people see photos of themselves in the nude I bet they never take another one."

It shouldn't be imagined, though, that snapshots are heading inexorably toward a pornographic horizon. As the processor concluded, "Sure you get the nudes and the other stuff, but I'm also seeing more snapshots of children, wakes, and sunsets. And animals, too. Last month a film came in of someone's pet cat, with a tuft of fur attached so we could match the color." Traditional family folksiness will doubtless be a feature of the snapshot idiom for a long time to come.

3

❧

The Quintessential Snapshot

The Qualities That Define A Snapshot

Of THE SNAPSHOTS YOU'VE SEEN in this book so far, you've probably accepted that they *are* snapshots, without question. It's interesting that this should be so. Most of them, certainly, are vaguely recognizable as the products of amateurs, but what are the distinguishing marks that prompt us to make our assumption? When is a photograph a snapshot?

We do not, of course, have this problem when we look through a friend's family album. We don't need to be told that what we are seeing are amateur snapshots, and because we're not required to make judgments about their status we have no cause to ever bother about the elements which, together, define a snapshot. The question only arises when we are confronted by anonymous photographs, about which we know nothing.

If we can, for a moment, shed our prejudices and look at a number of snapshots without the benefit of their owner's personal involvement, several things begin to happen. For a start, we are invited—if not impelled—to wonder about their meaning. We see the images as isolated photographs, not as visual aids to someone's commentary.

If we keep looking, we might also be struck by recurring similarities on the visual surface of the photographs—the image's graphic qualities as distinct from human or documentary content. But be

warned that patterns won't emerge immediately. There *is* a snapshot vernacular, but like the snapshots themselves, its arrangement tends to be chaotic.

Although obviously not a language, it is this unifying visual vernacular that helps us identify snapshots, just as listening to speech for a minute or two helps us identify a Welshman or an Arkansas farmer. The language is common; the consistency of variations from the standard form a secondary sense of order, if we learn what to look for.

What I'm going to attempt now is to isolate and describe some of the characteristics which make up the snapshot vernacular.

TILTED HORIZON

Few amateur photographers believe the world is flat, but a good many apparently believe it is not on the level. The angled horizon (or tilted frame) is a time-honored aberration in the language of snapshots, and perhaps one of the most conspicuous. Like "ain't" for

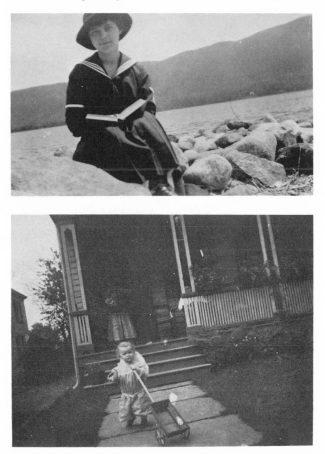

56. *Snapshots. American. Above: Emulsion print. c.1915. Below: Cyanotype. c.1905. TILTED HORIZON. A tilted sea might seem to be a glaring fault, but here it contributes to an interesting, if unorthodox, composition. In the shot of the child, the camera angle adds dynamism to what would otherwise be a dull, conventional picture.*

49

"isn't," it is accepted as being idiomatic, and from the vast number of tilted snapshots that survive, obviously nobody fusses too much about it.

UNCONVENTIONAL CROPPING

For half a century or more, amateurs peered through a peephole of some kind in their cameras and approximated the image they wished to preserve. It was a primitive aiming device and, not surprisingly, the picture that appeared on the emulsion was frequently not at all what the photographer had in mind. The center of attention was often barely captured within the frame. This is what the amateur calls "bad luck" but which we, rather more objectively, call inadvertent, capricious, or unconventional cropping.

This inadvertent cropping of the subject (not the print; few ama-

57. *Snapshot.*
American. 1920s.
UNCONVEN-
TIONAL CROPPING.
A common aberration,
often the fault of optical
imprecision but here
clearly due to the bifur-
cated intention of the
photographer. Wishing to
include both the car and
the man, he succeeds in
capturing neither.

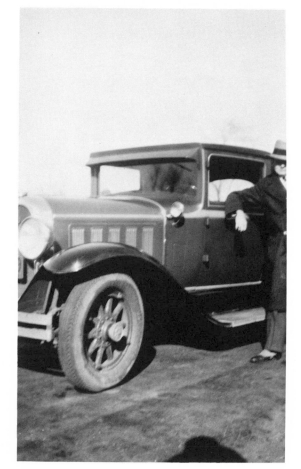

teurs ever trim their snapshots for aesthetic reasons) can have a curious effect; it frustrates our expectations and forces us to imagine what might be taking place outside the frame. It's the photographic parallel of a fleeting glimpse, when we "catch something out of the corner of our eye." If we're unable to take a second look we must use the image we retained to help complete the picture by conjecture.

Even with modern reflex cameras, which clearly show the photographer the shot he's going to get and even warn him about his safety margin, the cropped image has by no means been eliminated.

ECCENTRIC FRAMING

For the same reasons that produce idiosyncratic cropping, the amateur can bring forth a remarkable range of unorthodox framing effects. Most are with the subject in a position other than where it should obviously be, which is invariably in the middle of the picture area. Thus we have subjects popping up from the bottom of the frame, or for no visual or logical reason, at the extreme edges.

58. Snapshot. English. 1940s. EC-CENTRIC FRAMING. Although the position of the girl is unintentional, it doesn't offend. In fact, there are echoes here of Japanese scroll painting.

59. Snapshots. Above: American. 1981. Below: German. Albumen print. c.1900. THE DISTANT SUBJECT. A clear case of overkill, caused by the photographer's concern to make sure the subject is in shot. As a result the subject disappears into the middle distance. The lower snapshot achieves complete anonymity: two unidentifiable faces in an unknown sea!

THE DISTANT SUBJECT

Having gotten too close to the subject and lost it out of the frame, it's understandable that the amateur would subsequently proceed with greater caution. This produces the opposite effect to that of cropping, which is the "lonely figure" or "distant subject" syndrome—a person, for example, posed so far from the camera as to be unrecognizable and, occasionally, even invisible. This effect is heightened when the subject is posed against a background with the same tonal and textural values.

But the effect is not without a certain charm, often combining a scenic view and a portrait in a single picture. The distant subject can also be an enigmatic lonely figure in a cornfield, on a hillside, or a tiny head in an expanse of sea. Isn't man, after all, but a speck against the vast backdrop of nature?

BLURRING

Movement is an essential ingredient of life, and snapshots provide solid evidence of this. With today's fast films and shutter speeds the evidence is becoming less apparent, but so long as subject and photographer insist on moving violently at the wrong time, the blurring effect will always be with us.

Blurring, however, is not to be confused with the out-of-focus snapshot, strangely about the only kind a snapshooter will grudgingly toss away. There seems to be a sense of shame associated with unfocused images; either that, or the amateur has little use for romantic softness.

60. *Snapshot. American. 1970s.*
BLURRING. Blurring can be caused by movement of the camera, the subject, or the background. In this snapshot, all three factors seem to have contributed.

DOUBLE EXPOSURE

Accidental double exposures (called "montages" by professionals) are one of the most endearing aberrations in the snapshot vernacular and can result in a range of effects from the surreal to the hilarious. But the ghosts, regretfully, are those of yesteryear; with automatic cameras it is difficult, if not impossible, to double expose.

ENTER THE LIGHT

Light is both the life and death of the photographic process. It has the power to inflict wounds on many snapshots. It can attack in a blast of annihilating white from the edge of the frame, creep into an image like a cancerous growth, or announce its presence and mystery in the form of halation rings.

61. *Snapshot. English. c. 1935. DOUBLE EX-POSURE. Ghosts emerging from the castle ruins? Such accidental montages were common in the days before automatic cameras.*

62. *Snapshot. American. 1920s. LIGHT LEAK-AGE. A spectral arm reaching into the photo to claim its victim. . . ? No, merely the obliterating effect of uninvited light on the undeveloped negative.*

THE SIAMESE FRAME

Alas, modern cameras have also all but eliminated one of the most interesting of all snapshot phenomena, the "Siamese Frame." With preautomatic cameras it wasn't difficult to tear the sprocket holes in the film; when the operator advanced the film it refused to go forward a full frame, with interesting results. This common technical defect could produce bizarre pairings and juxtapositions, to our delight but undoubtedly to the despair of the photographer.

This happened to me once. When I asked why the laboratory hadn't spotted the fault and corrected it, I was told tartly by the druggist, "what you give me is what you get."

THE CLOSE ENCOUNTER

A finger looms large when it strays a millimeter or two in front of the camera lens, effectively obliterating most of the picture. But if the photograph manages to capture even a glimpse of the intended subject, the amateur will invariably keep it.

62A. (above) Snapshot. American. c. 1940. SIAMESE FRAME. Caused by torn sprocket holes in the film roll, so that each frame includes portions of adjoining frames. Such juxtapositions are often intriguing.

63. (right) Snapshot. American. 1981. OBSTRUCTED VIEW. A close encounter of the human kind—in this case a finger over the camera lens—is a common snapshot transgression.

64. *Snapshots. American. 1946 and c.1935. THE SHADOW. The shadow of the photographer in frame is his unintentional calling card. In the snapshot at left the shadow connects neatly with the subject. From the other photograph we can deduce that there were two people watching from outside the frame, one with a tripod-mounted camera.*

THE SHADOW

Everyone knows you must take photos with the sun behind you, which is one reason why so many frowning faces have skull-like black holes instead of eyes. It's also the reason why the shadow cast by the photographer insists on traveling along the ground and up into the picture. Such shadows, confirming the photographer's presence, are rarely a reason for discarding a snapshot.

*65. Snapshot. American. 1924.
BANALITY. A potentially interest-
ing subject, but the naive pose and
the unsympathetic background have
all helped to reduce it to a com-
monplace. Banality, to some degree,
could be said to exist in all snapshots.*

BANALITY

Banality has been suggested as a vital component in the snapshot vernacular, but it's a tricky characteristic. What is banal to somebody might be fresh or unique to another. The commonplace can't be easily dismissed; in a certain context we can find it insightful, enigmatic, surreal, or ironic. Because banality exists in the mind of the beholder and thus lurks in every image, it should be considered as a universal characteristic of snapshots.

AMBIGUITY

Of all the qualities we identify in snapshots, the most pervasive, most puzzling, most elusive, and yet the most engaging is that of ambiguity.

66. Snapshot. Kodacolor print. American. 1970s. Obviously there must have been some reason for taking this picture, but to us, as anonymous viewers, it is a complete mystery. We might imagine a dozen plausible reasons, and this is why most anonymous snapshots have an element of ambiguity.

Anyone who has thought about photography at all usually accepts that *any* photograph, to some degree or other, is a blend of the objective and the subjective. The dividing line is the problem. A professional photographer's preconceived intentions may, for instance, alter to a great extent our perception of the reality of the subject he is photographing; by contrast, the casual snapshot of an amateur may preserve what he sees in a faithful two-dimensional translation. But no photograph is a totally objective record of what the camera is pointed at. Merely aiming the camera from a certain standpoint, capturing the scene at a certain moment, even the *decision* to take the photograph— all these are subjective acts. The dilemma is that we can never accurately calculate or analyze the mix, and this in itself creates a basic level of ambiguity.

This ambiguity is multiplied, if you will, when the photographer (who at least has a firsthand relationship with his subject) delivers the photograph to a third party—the viewer. The viewer is now invited to relate to the subject through the photograph, and try as he might, he can't help being influenced by what he sees on the picture surface, which is quite a different thing from viewing reality in the flesh. A photograph, simply, is an image plucked out of its real context, and therein lies its essential ambiguity.

67. *Snapshot. English. 1920s. AMBIGUITY. A group of eight young women—but why? Who are they? What are they doing? Or going to do? There is little we can deduce from this snapshot; we can only speculate.*

68. *Snapshots. Source unknown. c. 1915. AMBIGUOUS SEQUENCE. It is difficult to avoid asking: "What's going on here?" Why the two similar snapshots? The unusual side-angle pose? Why is the lady wearing a coat in one shot but not in the other? Although taken within minutes of each other (from the shadows), which snapshot was taken first? These are just a few of the ambiguities that confront us in this sequence.*

With snapshots—and I am dealing here with snapshots one might pick up anywhere—the ambiguity is further enhanced by the anonymity of the subject matter (Who? Where?) and the unknown circumstances in which the photograph was taken (Why? When? How?). Now we have something that has an existence all its own, and it isn't surprising that it should pose more questions than offer answers. The image may contract with our disinterest or expand with our imagination and intuition. We may discard it or admire it for a hundred different reasons, but we may also never know exactly why.

The presence of ambiguity can be neatly tested by the adventurous imagination. Take any photograph you like, and invent half a dozen different stories about it, or the subject. The odds are that everyone will believe at least one of them.

This catalog of the flaws and foibles that characterize the visual surface of the snapshot genre is not to be thought of as a list of blameworthy transgressions. On the contrary, they've been observed, admired, and ultimately borrowed not only by celebrated artists but also by an acclaimed new school of contemporary photographers—a phenomenon we'll return to in later chapters.

4

❧❦

The Framed Victim

The Snapshot as Portraiture

A PORTRAIT OF SOMEBODY, in the painterly sense, is a visual impression of the sitter's appearance and personality, sometimes with overtones of flattery, satire, or psychological interpretation. Invariably it is as much an artist's statement as it is a representation of the subject.

The idea of a realistic portrait is fairly new. Six centuries ago a portrait was an expression of piety; a century later it reflected power and authority; later still any sitter who could afford it expected to be idealized. But the realistic portrait, as we know it, did not emerge until the latter half of the nineteenth century, when artists like Degas and Manet created and then drew on a much wider visual vocabulary to give many more layers of meaning to portraiture. Interestingly, photographic portraiture was developing at this time and, coincidentally, if you look at the black-and-white reproduction of Degas's portrait of the Duke and Duchess of Morbilli (69) you won't have too much difficulty imagining it as a photograph.

But a painted portrait is made to order according to the wishes of the sitter or the artist, while a photographic portrait is *taken.* The term is loaded, and you can see why in any number of snapshots of people. At a glance they appear to be at ease. But look closer, and you'll frequently observe, in the expressions and postures of the subjects,

69. *Edgar Degas (1834–1917).* Duke and Duchess of Morbilli. *Oil on canvas. Museum of Fine Arts, Boston. An early example of realistic portraiture in painting.*

that they show all the signs of being the unwilling prey of the camera lens.

Not without some reason are primitive people suspicious and even fearful of the camera. Look, for example, at the nineteenth-century photograph of a beheading in China (70). Even though it may not have been the stomach-churning spectacle it would be today, it is astonishing that, almost without exception, the crowd is gazing at the photographer and his camera and not at the unfortunate victim.

It is possible that modern industrial man still retains vestiges of this instinctive primal fear, regarding the taking of a photograph as an aggressive action, a violation of privacy. It is, after all, *his* image that is taken from him. What might happen to it? This is a question that increasingly addresses itself to celebrities who, in hostile moments, will physically attack a press photographer though rarely the accompanying journalist who is capable of more damaging, invented malice.

The effect of a photographer's transcendent power is not merely confined to primitives and the uncultivated. In his poem *The Photo-*

70. *W. Sanders (attr.)* Execution Scene, Shanghai. *Albumen print. c. 1870. Notice how the onlookers are watching the cameraman, not the grisly event about to take place.*

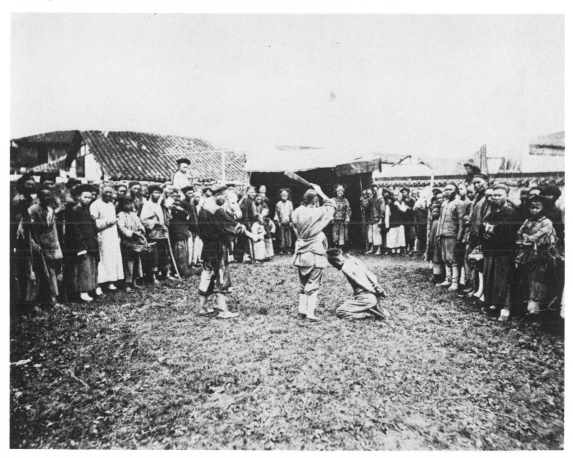

graph (1913), Thomas Hardy describes his feelings when he burns a snapshot of a loved one; he suddenly cries out with grief and can't bear to look at the flames—as though they are consuming something of the subject, not just his memories.

This wariness of the camera and its product is also often evident in photographs of young children, who almost always need to be coaxed by a parent to be their normal, happy selves. The easiest way to capture an unaffected and joyful shot of children is to catch them unaware—in other words, to *steal* the shot. But to ask some children

71. Snapshot. Toned silver print. American. 1906. Despite parental coaxing from outside the frame, the child is apprehensive of the camera.

72. *Dr. Barnardo's Studio. Sarah Burge. London. 1883. Barnardo Photo Library. Sarah's hostility toward society—represented by the camera—is painfully evident. Dr. Barnardo used such photographs of waifs to attract publicity and funds for his child welfare work.*

73. *Snapshot. French. c.1920. The little girl displays anxiety and resentment in her confrontation with the camera. Her expression could have been transferred from the Sarah Burge photograph, taken forty years before.*

to confront the camera is to invite uncertainty and even outright hostility. Two remarkably similar shots illustrate this, even though they were taken half a century apart—that of Dr. Barnardo's Studio portrait of Sarah Burge (72) and the other of a little French girl in sailor costume (73). In both cases the apprehensive eyes reveal feelings not far removed from instinctive mistrust. Today, though, many children are so accustomed to having snapshots taken of them that they will gleefully "ham it up" for the camera.

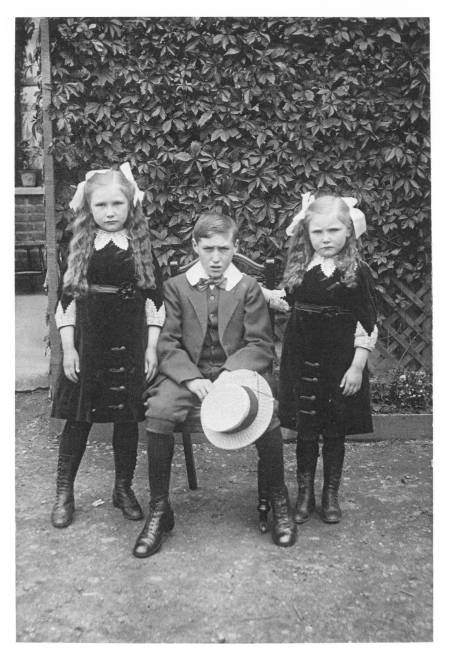

74. *Snapshot. English. c. 1900. The uniformity of worried, irritated expressions on the faces of the three children indicates that their contest with the camera was something of a trial.*

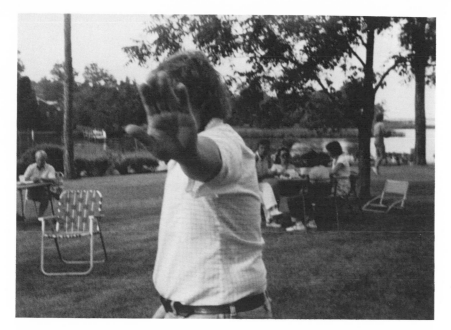

75. *Snapshot. Kodacolor print. American. 1980. Many people—for reasons of shyness or some real or imagined physical defect—go through life treating the camera as if it were a plague carrier.*

As we grow older, of course, we learn that the only way a camera can hurt us is to catch us in the act of being afraid or embarrassed, and we evolve various ploys to avoid this. Some people, like the young man snapped at a picnic (75), simply block the camera's view with a shielding hand.

Other victims, seemingly confident, betray their instinctive mistrust through the body's reliable barometer of stress, the eyelids. Try as we might, it is almost impossible to stop blinking. Behavioral psychologists tell us that we blink at a faster rate when we are nervous, which may be why many snapshots show people with their eyes closed. A photograph, then, can reveal something about ourselves that we can see in no other way—it can catch us in the act of blinking.

Almost all snapshot portraiture exhibits a range of stratagems designed to avoid the unvarnished confrontation with the lens, from moving or turning away at the crucial moment, backing away from the camera so that details of the face will be lost, or, as a last card, by deliberately looking foolish.

These are what I call "Fooling Around" snapshots, and they are quite common. Usually the device is simple and spontaneous, utilizing whatever is at hand—pulling a face, striking a crazy pose, suddenly

76. *Snapshot. American. 1980. Blinking is the one physical act that eludes our self-control when posing for a camera. It is a sure barometer of stress, and "blinking" snapshots are quite common.*

kissing the adjacent person, and so forth. A good many people, though, go to the trouble of dressing up; any sort of costume acts as a suitable disguise.

Another common stratagem to deflect the camera's scrutiny is for the subject, consciously and unconsciously, to influence the choice of background. You don't have to view many snapshots to conclude that most backgrounds are busy and distracting. When we view a professionally taken photograph, the background is invariably plain or plays an important role in the composition. A figure placed in front of a plain backdrop helps focus our attention on the subject, giving us the opportunity to pick up clues to personality and character. Gestures, attitudes, expressions, and personal defects show up with greater clarity. So do the clues to relationships between people—barely discernible tensions, physical ties, body positioning, contact among other people in the snapshot, and the positioning of hands and limbs.

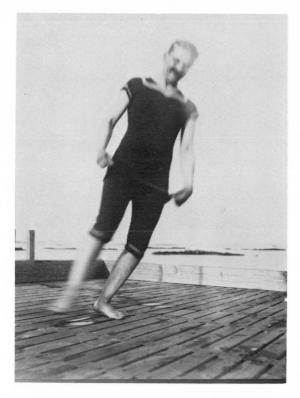

77. *Snapshot. Albumen print. American. c.1895.
An early "fooling about" snapshot in which im-
promptu antics effectively disguise nervousness.*

78. *Snapshot. American. c.1920. This quartet has
neatly slipped into a visual joke routine to avoid the
embarrassment of being thought pompously serious.*

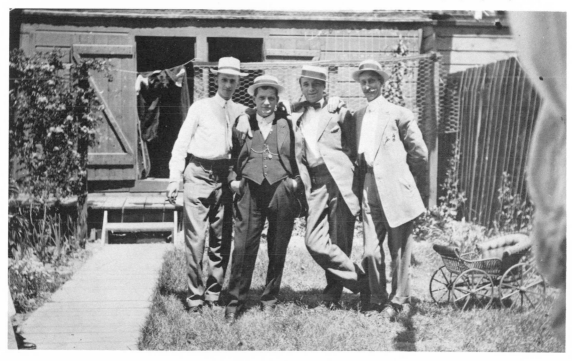

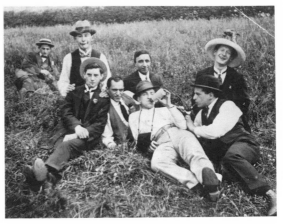

79. *Snapshot. American. Kodacolor print. 1980. While the young lady exudes a look of smiling self-confidence, we suspect it was made possible by the impromptu disguise.*

80. *Toned print. English. c.1920. With the exception of the man at the rear, the subjects have gone to considerable trouble to avoid being trapped in a serious group photograph.*

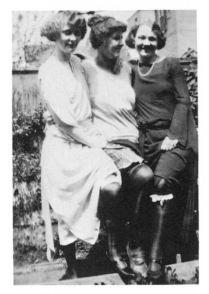

81. *Snapshot. American. c.1925. Backyard frolics and somewhat modest exposure are stock shields against attack by the earnest photo taker.*

82. *Snapshot. Toned print. India. c.1925. Any convenient props at hand are used to defend against seriousness.*

83. *Snapshot. German. 1930s. The Germans take their fooling about seriously. Note the Hitler mustache on the young woman on the left—a comment on the times?*

With snapshots, though, plain backgrounds are relatively rare. The amateur tends to load his picture with visual clutter. From the subject's point of view, the more interesting and distracting the backdrop, the less intense the viewer's gaze, and this suits him fine. And if the background or surroundings help to enhance the subject's material or social status, so much the better.

We have already seen how a person's home is used in a typical family photograph to reinforce a subject's achievement of prosperity. If we progressively narrow our view of a house, we inevitably arrive at the porch and doorway. That small area alone effectively symbolizes the whole house. It also provides the perfect frame for portraiture; even the most inept amateur can see through his viewfinder that a couple of figures in a porch or doorway make a satisfying picture. Compositionally, the door frame has the effect of preventing the eye from wandering; it pulls the eye toward the people in the frame and holds it there.

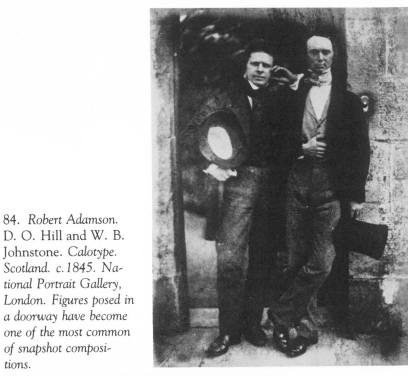

84. *Robert Adamson.*
D. O. Hill and W. B.
Johnstone. *Calotype.*
Scotland. c.1845. Na-
tional Portrait Gallery,
London. Figures posed in
a doorway have become
one of the most common
of snapshot composi-
tions.

85. O. G. Rejlander.
Girl at a Window.
Albumen print. English.
c.1864. Gernsheim Col-
lection, University of
Texas. The forerunner
of another popular snap-
shot composition: posing
in a window frame.

This device is just about as old as photography itself. The Adamson calotype of D. O. Hill and W. B. Johnstone dates from 1845 (84) and sets the example for millions of similar such professional and amateur doorway shots. Similarly, O. G. Rejlander's *Girl at a Window* of 1864 (85) uses a window frame for a slightly more romantic effect. Both subject and photographer seem to gravitate toward the domestic rectangle; the subject because it diffuses his own persona, and the photographer because it assures him of an attractive, if conventional, composition.

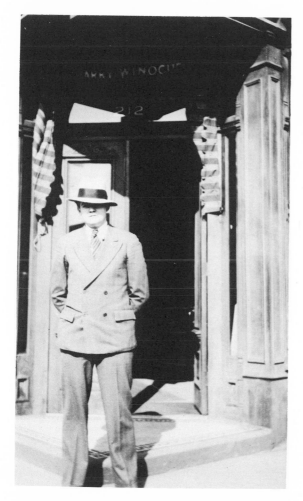

86. *Snapshot. American. c.1925. An exceptional "doorway portrait" which instantly attracts the eye with its play of angular shapes behind the figure. Yet the man is an integral part of the picture, an amalgam of personality, time, and place.*

87. *Snapshot. Albumen print. German. c.1910. A marriage of subject and environment. The doorway provides the essential element in an appealing, well-balanced composition.*

88. *Snapshot. Welsh. c.1905. A charming "doorway portrait" in which the porch supplies many clues to the old couple's environment and way of life.*

89. *Toned print. English. 1908. Although dominated by the botanical facade, the woman is still the key element in this "doorway" portrait.*

90. *Snapshot. Toned print. English. c.1900. A typical "window shot," framing, presumably, the occupants of the house. Note the remarkable range of expressions: unease (man, extreme left); boredom (man, extreme right); stoicism in the face of the enemy (the other three men); self-conscious projection (woman, second from left); and doubt (woman, extreme right).*

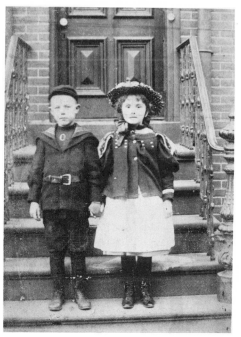

91. *Snapshot. Albumen print. American. c.1895. A delightful portrait of two children, using the house steps, railings, and the front door to supply formal contrast to the figures. Posing children on steps is not without symbolic significance.*

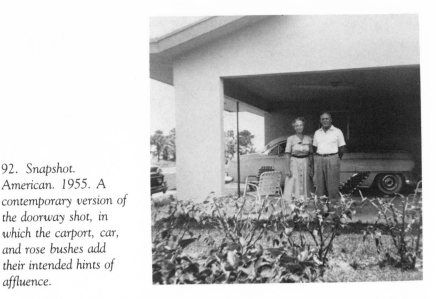

92. Snapshot. American. 1955. A contemporary version of the doorway shot, in which the carport, car, and rose bushes add their intended hints of affluence.

But there are other common backdrops, too, that are rather more ambiguous, causing us to ask questions. Was the background deliberately chosen for some reason? Was it intended to reinforce the identity of place or occasion? Was it selected for compositional reasons, to highlight a white dress against a dark hedge? Or, more intriguingly, was the background a wholly subconscious choice?

I am, for instance, fascinated by the ubiquity of spiky vegetation as a background (93, 94, 95). I come across it quite often—far more often than one could reasonably expect. What does it mean? Is there a sort of subconscious symbolism at work here?

Far stranger, though, is the snapshot phenomenon of people in trees. One can, admittedly, rationalize a meaning behind the old gentleman sitting in the fork of an immense tree (96). From his appearance of confidence and his work boots, one might assume he's a gardener or forest worker, and that the photograph simply marries the subject to his workaday environment. The same rationale could apply to the candid shot of the lady atop a ladder (97) who could be pruning or picking fruit.

But it is difficult to explain why the ladies in the other two snapshots (98, 99) are in trees. None of them had an easy climb, nor were they suitably dressed for it. Yet there they are, perched at some risk at a considerable distance from the ground, for the sole purpose of having their photographs taken.

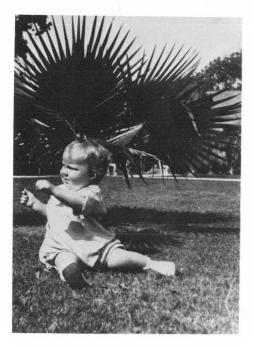

93. *Snapshot. American.
c.1925. Deliberate, and unfortunate, use of the spiky plant as
a background gives the picture a
surreal quality.*

94. *Snapshot. American. 1926. Another spiky
backdrop. Look at the photo through half-closed eyes
and you'll see a magnificent native headdress.*

95. *Snapshot. American. c.1940. Now the subject
has sprouted feathered wings! One wonders about the
motivation that prompts selection of such unsympathetic backgrounds.*

96. *Snapshot. Toned print. English. 1906. The Old Man of the Tree: an excellent example of the "people in trees" variety of snapshot.*

97. *Snapshot. Albumen print. American. c. 1895. For some obscure reason, snapping people perched above the ground has a mysterious attraction for amateur photographers.*

98. *Snapshot. American. c. 1910. The quest for height, notwithstanding the difficulty of the climb and the unsuitability of attire.*

99. *Snapshot. Albumen print. American. c. 1895. An even more difficult climb and precarious position.*

THE FRAMED VICTIM • 79

The ancestor of the snapshot portrait was, of course, the studio portrait, the popular vogue for which began in the mid-nineteenth century. And in contrast to the casual snapshot, the studio portrait ensured an image that was positively distinguished in appearance. The sitter made every effort to preserve the finest possible likeness of himself, believing, as an 1862 *Punch* wit suggested:

> *Depicted by the solar rays,*
> *What loveliness this form displays!*
> *The figure, what surpassing grace!*
> *What radiant harmony the face!*
> *This portrait as it is will last;*
> *And, when some twice ten years have passed,*
> *Will truly show you what you were,*
> *How elegant, how fresh and fair . . .*

This type of image would be protected by trusted hands, enshrined in a costly frame or mounted in a gilt-edged, morocco leather, brass-

100. *Studio portrait. English. c. 1900. Grim, fixed expressions were a distinctive feature of studio portraiture. Because of the facial masks and the fictitious backdrop, there is very little we can learn about the subjects from such photographs.*

clasped, Bible-dimensioned album some four or five inches thick, for the wonderment and admiration of future generations. Even a hundred years later, the attitudes of sitter and portraitist have barely changed. The photographer Richard Avedon, famous for his portraits, prefers to work in the studio. This isolates people from their environment, so his pictures are not so much likenesses as symbols of his subjects. As always, the professional photograph tells us as much about the photographer as the sitter.

Also missing from snapshot portraits are the heroic props of grand portraiture—the heavy antique furniture, massive flowing draperies, floral displays, and classic landscapes viewed through a window—all of which were liberally borrowed by the studio photographers. It is no accident that there's a Rembrandt Photo Studio in just about every Western city and town! Missing, too, from the snapshot are the traditional studio poses: wife seated with husband standing with hand resting on the back of the chair, and (for some reason) vice versa. For almost a century, and from Austria to Australia, from Prague to Peoria, the poses and expressions struck in tens of thousands of studios are as predictable and repetitive as the tides.

This sameness is a feature of studio-posed portraits; the formal poses and fixed expressions contribute to a numbing uniformity whether the photograph is a nineteenth-century cabinet card or a lovingly framed color study of more recent years. Nor is this uniformity threatened in any way by the age and sex of the sitters. A quite dramatic demonstration of this is illustrated in Plate 101 which shows four photographs of a brother and sister, each taken about a year apart. If we close our eyes to the fact that the little boy and girl have grown between each photograph, they could all have been taken at the same sitting.

Even when an effort is made to break out of the studio mold, the overall effect of homogenized tedium remains—witness the two "cowboys" (102). Between the human subjects and the horse, can you pick the live ones? Such portraits, obscured under layers of convention and make-believe, make it impossible for us to read them intelligently. They offer few clues about the sitters' personalities, or what they did, or how they lived.

By contrast, snapshots are, as a group, refreshing and infinitely more rewarding. Take a look at the lady standing on a pier at the seaside (103). Its unconventional composition is light-years removed from a studio setup—the ungainly but arresting central figure, the counterpoint of horizontal lines, a rhythm picked up by the buttons on

101. *Studio portraits. English. c.1940s. These four portraits of a brother and sister were each taken about a year apart and illustrate the homogeneity inherent in much studio photography.*

102. *Studio photograph. English. c. 1930. The two human subjects are about as animated as the stuffed horse. Frozen gestures and expressions are not uncommon defects of the studio portrait.*

103. *Snapshot. English. c. 1920. In refreshing contrast to studio photographs, snapshot portraits offer much more of interest. In this case we have a simple, bold composition, an enigmatic expression, and a seaside parody, all in one.*

the coat and hat, the symmetry of the bold mass surrounded by space. Although the most commonplace of snapshots, its composition is worthy of a David Hockney, its subject's head-on collision with the camera worthy of an August Sander. Then there is the face: shy, unassuming, and ultimately enigmatic. And, finally, on another layer, the image is a marvelous parody of all such seaside mementoes: dressed for a winter's day, why is she at the seaside anyway? And all this from a single snapshot!

Now that we're alerted to the avoidance ploys used by people when confronted by a camera, we're in a better position to tackle the paradox of the supremely confident subject. For don't be misled—this confidence is yet another stratagem to defeat the camera's prying gaze, and most of us manage to acquire it to some degree. The young woman with hand on hip (104) appears to have no fears. A kindred self-assurance radiates from the 1925 portrait of a German couple (105). The man, especially, with his set mouth, and feet stamped into the ground, projects a smug self-importance that no camera lens could ever destroy. The young man standing with spread legs (106) takes us all the way up the scale to arrogance. It should surprise nobody that the subject is German and that the snapshot was taken in 1932. Can we help wondering, did he become a Nazi?

As one sifts through thousands of snapshots one begins to see nuances that previously escaped attention. In snapshot portraits, for instance, if there is an intensity in some that is missing in others, it may be that certain people are able to channel their energies and project, as an actor does, a persona to the unseen audience. The subject, and not the camera or photographer, is in control. Look at the twin snapshots (107) of a man and his wife; the woman responds to the camera in a most assured way while the man is uneasy. She has developed a photographic persona which she can project spontaneously; her husband is like someone who is suddenly asked to make a speech in front of a crowd and stands there bewildered and tongue-tied.

But if familiarity with snapshots can teach us interesting things about people in portraits, we also soon learn to be suspicious of theories. We have seen how people can react in a variety of ways when they are photographed, which may or may not reveal their true personalities or feelings at the time. We really have no way of knowing.

105. *Snapshot. Toned print. German. 1925. No self-doubt here! The couple are comfortable and assertive before the camera, and we have little doubt they are two strong personalities.*

104. *Snapshot. English. c. 1925. Any innate shyness here is disguised by a projection of confidence; both pose and expression are assured. Note, too, how compositional elements reinforce the pose of the figure.*

And often we don't know why a particular snapshot was taken—its motive—or why it survived. We must take into account the fact of editorial selection. This may be the reason why one does not see many really ugly people in snapshots. Perhaps they simply avoid the camera at all times. Through the homogenization of the human face in entertainment and advertising, we are led to believe that intelligence, honesty, competence, and pleasant personality reside only in the faces

106. *Snapshot. German. 1932. The brashness of the young man echoes the arrogance of official Nazi propaganda portraits of the Aryan ideal during the 1930s.*

107. *Snapshots. American. c. 1940. Obviously a married couple, but while the woman easily projects her photographic persona to the camera, her husband is visually speechless. These snapshots, incidentally, offer credibility to the theory that married couples, after many years together, begin to look alike.*

of the good-looking. Obviously many snapshots never see the light of day; only the permissible images survive in family albums, and this adds yet another ambivalent layer through which we must peer to get at the truth.

One researcher who has attempted to break through this ambiguous barrier is Dr. Robert Akeret, an American psychoanalyst who for many years has used his patients' personal snapshots as an aid to psychotherapy. This led him into a closer study of personal photos and their hidden psychological meanings and to the creation of a series of techniques which he calls photoanalysis. With these techniques, Dr. Akeret claims, one can, from clues in snapshots (body positioning in group shots, the way arms hang, touching, leaning away from another person, etc.) divine the nature of family relationships, sibling rivalry, aggressive tendencies, and so forth. But while these methods may lead us some of the way toward understanding snapshot portraits, snapshot ambiguity will defy them all in the end.

A couple of random examples aptly illustrate this. The pair of snapshots in Plates 108 and 109 show two families. The first, of parents and their child, tells me (this is my own intuitive reading) it is a family riven by tensions. The apartness of the three individuals is quite pronounced. The mother is rigid, the child is apprehensive, and

108. *Snapshot. English. c. 1930. Do you detect an unsettling element in this photograph, with the dominating father, meek mother, and nervous child? Or are we emotionally influenced by their serious faces and the chaotic background?*

109. *Snapshot. English. c.1920s. In contrast to the previous snapshot, this trio suggests to us that they are secure, tolerant, happy, and comfortable with one another. But can we ever be sure?*

the father would rather be somewhere else. The second snapshot, also of three family members, appears by contrast to be a portrait of three contented people, each comfortable with the other despite their physical apartness. But can I be sure? Has my reading of the first photograph been emotionally tilted by the maelstrom of leaves in the background? Has my reading of the second photograph been influenced by the three smiling faces and the man's arm extended toward his wife? Photographic ambiguity frustrates positive answers.

The next pair of photographs almost have the effect of shouting their message (110, 111). The soldier and his wife are in separate worlds; each is cocooned in his or her uniform with full regalia, and their apartness is profound. The man and the child, although there is no body contact, give the impression of being closely tied; the child's cane cutely parodying the symbol of old age. But as with the previous

pair of snapshots, this reading could be wildly inaccurate. The woman beside the soldier might be his mother, sister, or aunt; the man with the child could be a distant relative from overseas who is meeting the little boy for the first time.

While the truth behind all four snapshots may elude us, we can, however, appreciate them as *anonymous* portraits, for what they are and not for what they might seem. And that, for me at least, is the payoff, for I frequently find that the most engaging snapshot portraits are those which defy analysis.

110. *Snapshot. Albumen print. English. c.1905. At first glance a portrait of husband and wife. Their "uniforms" isolate them from each other and emphasize a disconcerting apartness. But there is much ambiguity in the photograph which much lead us to question our assumptions.*

111. *Snapshot. Toned print. English. 1930s. A compelling image in which the links and contrasts between the man and child attract us. But, again, photographic ambiguity prevents us from reading this snapshot with any assurance.*

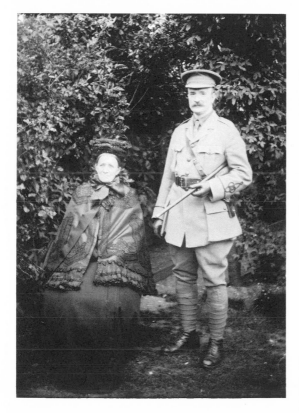

To grasp some of the important subtleties of great portraiture, it may be instructive to study the work of the American Mike Disfarmer. A decade ago, Disfarmer was unknown except to the folks of rural Heber Springs, Arkansas. There, from the 1930s until he died in 1959, he took pictures of the locals in his sky-lit studio for fifty cents a sitting. The extraordinary thing is how this untrained, unsophisticated, and untraveled man produced hundreds, if not thousands, of remarkable and intensely penetrating portraits that rank with the best of such luminaries as Diane Arbus and August Sander.

If you glance even casually at a typical Disfarmer group (112), you can't help noticing something unusual about it. It grabs you; it produces vibrations. Why, then, can so few photographers capture and transmit this electricity while thousands of clever professionals, despite their undoubted talents and training, simply cannot? The secret, according to New York critic Howard Smith, is really straightforward: "The photographer just looks through the lens with intense magic until the person posing is transformed into a timeless work of art. At that exact moment the shutter is released." Disfarmer, Smith added, "without articulating it or understanding how, taught the people of Heber Springs that the way to pose for an important picture is to know how to let go of your face."

112. *Michael Disfarmer.* Rural Family, Heber Springs, Arkansas. *1940s. A typical group by the remarkable, recently rediscovered folk portraitist Mike Disfarmer, who transformed poverty into images that are sublimely truthful, eloquent, and touching.*

91

5

❧❀❧

The Main Event

The Snapshot as Immortalizer

A WEDDING—the public celebration of a marriage—is probably the most personally important ceremony in most people's lives. It is also an occasion on which many colorful, inexplicable, and expensive customs continue to be preserved. Even at nudist weddings, I'm informed, the brides wear veils. The formal suits, the ornamented gowns, the family pecking orders, the reception, the speeches, the jokey telegrams, the cake cutting, the bouquet tossing, the honeymoon—little wonder there exists a desire to eternalize it all with photographs.

Though the full-blown church wedding is rather less in demand than it used to be, most marriages are attended by some sort of celebration, even if it's only drinks with a few friends. But however diminished the ceremony, it is almost certain to be recorded with photographs. My second marriage was hastily performed in the New York Criminal Court building, but this didn't deter one of the witnesses from snapping a dozen Polaroids of the occasion in the judge's chambers. In whatever form it takes, a wedding is a "main event," and an irresistible stirrer of the photographic instinct.

Although daguerreotypes of newly married couples exist, weddings were not initially thought suitable for photography, at least until the

1850s and the tintype era. In fact, wedding photographs are rarely found before the 1870s and even then they are almost exclusively of middle-class and society couples.

With the popularization of amateur photography at the turn of the century, however, the solemn large-plate photographs were joined by snapshots taken by family and friends, and it is with these that we shall concern ourselves.

Most weddings were, and many probably still are, recorded by professional studios, which now follow the event from the first fitting of the bridal gown to the stock shot of the couple's shoes outside the honeymoon hotel bedroom door. But simultaneously there is a chorus of amateur clicking, and it is here that the true essence of a wedding is captured, as distinct from the formal and romanticized images the couple eventually receives in the professional album. The growing threat of the amateur was initially fended off by the professionals who began to offer candids or "casuals" together with the "formals" and "misties"—soft-focus shots. But the proliferation of fast cameras and universal flash is inevitably winning the day for the snap shooters. The immaculately posed, unnervingly formal, and impeccably developed wedding photograph may, in not so many years, become a collector's item.

Perhaps the glossy impersonality of the formal wedding coverage is to blame for its declining popularity. One professional remembered a wedding where the bridegroom was injured just before the event. A private ceremony was promptly organized at his bedside, but the big reception went on just the same. "You know," the photographer mused, "no one missed the groom at all, and you don't even miss him in the pictures except in the wedding cake scene."

It is instructive to compare professional photographs of a wedding with snapshots taken by family and friends. In the professional photos (113, 114) one can't help but be struck by the sameness of expressions on the faces, from bride and groom all the way to the flower girls. It is, what's more, a standard look, with all the participants mouthing "cheese" to summon up smiles that are fixed and uncertain, perhaps reflecting Dr. Johnson's view of marriage, "a triumph of hope over experience."

The informal, amateur "backyard" wedding photo, on the other hand, does seem to capture the genuine emotions of those concerned. The group in Plate 115 is typical, dropped, as it were, from fairyland

113. *Professional hand-tinted photograph. English. 1940s. The formality, the symmetry, and the consistency of pose and expression are designed to separate the ceremonial group from reality.*

into the drab surroundings of reality. The expressions are about what you'd expect—disoriented, apprehensive, but trying to look cheerful—and it is fairly obvious the brief party is over.

The studio portrait of the couple in Plate 116 is even more to the point. The young marrieds appear to have stepped behind elaborate cutouts of wedding finery kept in the studio for such occasions. All animation has ceased, the expressions are ossified, and we can tell as much about their thoughts as we might from a marble statue.

But compare almost identical bride and groom snapshots taken by amateurs in more familiar environments. There is still the same intention to appear formal, but the formality is never the mask it is in

114. *Professional photograph. American. c.1960. Doubtless the photographer requested all the participants to "say cheese" in order to capture the regulation wedding group smile.*

115. *Snapshot. English. 1917. Compare this do-it-yourself wedding group with the professional studies. The party seems to have tumbled out of a fairytale into drab reality.*

116. Studio photograph. Welsh. c.1925. The clothes are impeccable, the expressions are sanitized of all emotion, and the poses are petrified; any detail that might tell us something about this couple has been stringently excluded.

the studio. The details that are expurgated in studio shots are left in. The little mat, for example, in Plate 117; the barren but carefully swept corner of a yard (118); and the fresh lace curtain in the window behind. These are telling pictures, of fantasy betrayed by grim reality.

In half a century little has changed. Examine the quartet of Kodachrome prints of a 1960s wedding reception (119). The occasion is magical for the couple; it is the high point in their lives. But see how the rather tawdry surroundings bring everything down to earth. This is exactly what a studio photograph does *not* do; it romanticizes and idealizes by separating the couple from everything resembling the reality of their lives before and after. As Janet Malcolm observes in her book of essays on the aesthetics of photography (*Diana & Nikon,*

117. *Snapshot. English. 1920s. Although intended to be a formal memento, this backyard snapshot preserves sufficient detail to tell us about the reality of the couple's lives. Note the floor mat, which substitutes for the studio carpet.*

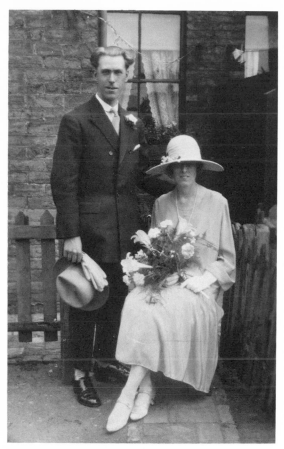

118. *Snapshot. English. 1920s. Striving for conventional formality—the stereotyped pose, the delicately placed feet of the bride, the ambivalent expressions—this couple is nevertheless betrayed by the grim ordinariness of their surroundings.*

119. *Snapshots. Kodachromes. American. c.1960. The bride looks radiant, but the gauche surroundings destroy much of the glamor of the occasion. Snapshots are great levelers.*

120. *Snapshot. German. 1928. We have no idea what the occasion was, but from the cake, wine, cigars, and the shiny, well-fed faces, we assume it was a significant event, perhaps an anniversary.*

David R. Godine, Boston, 1980), "We have all had the experience of being appalled by the Polaroid or Instamatic snapshots that someone has taken at a party, in which not only we ourselves look terrible but our surroundings do, too. The pleasant and sometimes even expensively furnished room we're sitting in has been transformed into a hideous and cheap-looking mess of lamp cords, wall outlets, TV antennas, cigarette brand names, creased upholstery, dirty plates and glasses, spindly table legs . . . our Kodacolor snapshots delight in telling us what we do not want to know—that we are all the same."

A "main event" in our lives is of course something we largely create ourselves. It is a celebratory event which we think about a good deal

121. *Snapshot. American. 1949. Taken before the "main event," this unusual snapshot of a girl's sixth birthday party records the occasion with the formality of a still life.*

before and want to remember for a long while afterwards. One might define it as an occasion for which we will want a photographic rec-ord—an important anniversary party, for example—and this impulse hasn't changed much since people learned to take pictures.

Even at a young age we are impressed by the need for the camera's presence on such occasions as birthdays and Christmas. American photographer Tod Papageorge remembers Christmas when he was a child: "On Christmas mornings my father was a photographer . . . my sister and I, called to attention, stared ferociously at those awful bulbs, not understanding that even as we sat there, blooming from the rib-bons and wrapping paper, we were part of a ceremony; that we were, in fact, its motive."

The "main event" has been, and probably always will be, a prime *raison d'être* for the snapshot which is not, after all, intended to record and preserve life's disappointments. Clearly the snapshot ignores a large and important side of our lives. Although I know they must exist, I've never seen a snapshot taken at a funeral or inside a hospital, obviously because images of such occasions give us none of the succor or support that happy snapshots do.

122. *Snapshots. American. 1950s. Taking snap-shots allows adults to participate vicariously in something they can never recapture: the joy and wonder of children at Christmas.*

6

⤫❧⤬

The Modern Madonna
Mother and Child in Snapshots

THERE ARE GOOD REASONS to suppose that contemporary Western society's attitude toward young children was invented by the Victorians. They certainly made a cult out of childhood and built an industry around it. From the thousands of books written especially for children to the sentimental images of them produced by artists (Kate Greenaway) and photographers (Lewis Carroll), it is not surprising that, since then, young children have been regarded somewhat as a separate species.

This is particularly true when we consider childhood as portrayed in snapshots. They display, quite conspicuously, a desire on the part of the photographer (usually a parent or relative) to exemplify innocence, a carry-over from the Victorian perception, and a beloved fantasy of adulthood. One also feels, after looking at hundreds of these images, that the child is not so much a little person as a living idol, dressed in elaborate clothing and preciously cradled in the loving mother's arms.

There is, for example, right through snapshot history, the pervasive image of the Modern Madonna—snapshots of mother and child that remind us of nothing less than Mary and the Infant Jesus as painted by Giotto or Jan Van Eyck in the traditional pose of the child cradled on

123. *Jan Van Eyck.* The Ince Hall Madonna. *Flemish. Fifteenth century. National Gallery of Victoria, Australia. For almost two millenia, the Madonna and Child has inspired the stock pose of a mother and her baby.*

the mother's lap (123). This powerful imagery of woman as mother has been around since the Byzantine era, and it persuades us, despite feminist efforts to change our attitude, that having a child is a woman's sacred role. Thus any photograph of a mother with her child is in its way an all-embracing icon, symbolizing life, love, happiness, fertility, and human purpose.

*124. Snapshot. English.
c. 1915. The traditional
Madonna and Child pose
in common in snapshots.*

It's quite possible there's a correlation between the world's birthrate
and Kodak profits, for the birth of a child was, and maybe still is,
sufficient reason to go out and buy a camera. From my observations, at
least a third of all snapshots are concerned with young children.
Intriguingly, as if to demonstrate the distance between its aesthetic
based philosophy and photography in real life, only a few hundred of
the 20,000 photographs in the Museum of Modern Art collection
feature children.

The addition of a baby to a household signals the release of a range
of complex emotions and attitudes, from tender love to fierce pos-
sessiveness, and nowhere is this better documented than in snapshots.
Photographs of children are possibly more interesting and revealing
than any other kind of snapshots; they possess, however indefinable,

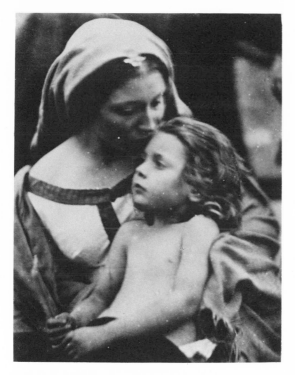

125. *Julia Margaret Cameron. La Beata. English. 1864. National Portrait Gallery, London. With images such as this, the Victorians began the process of sentimentalizing childhood.*

126. *Snapshot. Sepia-toned print. German. 1910. Sometimes an amateur photograph transcends its snapshot status, but few baby snapshots are as beautiful as this one.*

127. *Snapshot. English. c. 1925. An unconscious imitation of the classic mother and child pose, but reality intrudes. Note the baby's pacifier, the girl's bandaged knee, the little boy's screwed-up trousers, the mother's dirty shoes. Yet it is an honest and delightful picture for all that.*

128. *Snapshot. Sepia-toned print. English. c. 1910. A superb study of a mother and her child in the drabbest of surroundings. One can see the swept brick pathway and polished chair in an attempt to hide the signs of poverty.*

129. *Snapshot. American. c. 1925. Two millenia from the painterly images of the Madonna and Child, this version, with the mother almost cropped out of the frame, is pure snapology.*

an intrinsic magic. Having children stirs the photographic impulse in parents to an insatiable fervor.

One question snapshots help to answer is whether children change from generation to generation and whether their parents' attitudes toward them change. As a generalization, they don't. Snapshots of babies and young children seem to be timeless. The clothing and surroundings may change but the essential images alter hardly at all. Even with the advantage of flash photography, permitting a candidness not previously achievable, childhood is still presented much as it always has been.

Perhaps this timeless aspect of the baby snapshot is itself directly related to time: that powerful, postnatal urge to record a baby's existence while it remains a baby. Parents seem impelled to go to any lengths to satisfy this urge, and a vast number of very bad, very inept baby pictures are the result: baby sleeping, baby in the stroller, baby being bathed, baby dribbling—no doubt you've seen them all. Or perhaps "seeing" is a misnomer; many baby pictures are of a distant, barely identifiable little face swathed in cap and blankets (130). The sleeping, out-of-focus baby in Plate 131 is about the worst baby photo

130. *Snapshots. American. c.1940 (above); 1920s (below). Most baby pictures are the result of an irresistible photographic impulse on the part of the parents, rather than an objective desire to record a baby's growth. Consequently most baby snapshots are uninformative, almost anonymous, images.*

131. *Snapshot. American. c.1930. Out of focus and unidentifiable, this is a typically bad baby snapshot.*

132. *Snapshot. Kodacolor. American. 1968. Pride, delight, and possessiveness are all aggressively inherent in most grandparent and child pictures.*

I've ever encountered, but it is by no means untypical. Yet it was treasured sufficiently to earn for itself a place in a family album for three generations.

From the evidence in baby snapshots, the mother is not without competition. Grandparents undoubtedly feel they've earned a special place in the baby's life. Snapshots of grandparents with baby (132) have a special look all their own, often riding a fine line between glowing love and greed. What's more, if starved for baby contact they may, armed with a camera, wreak savage vengeance—as you can readily see in the two snapshots of mother and baby with the mothers' heads out of frame (133, 134). To be fair, though, such examples of

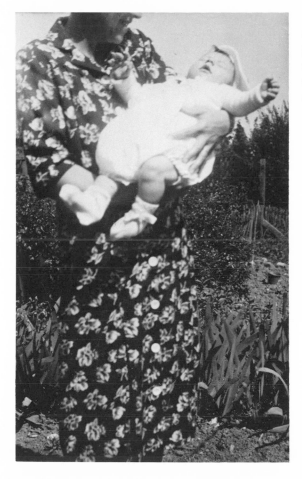

133. *Snapshot. English. c. 1940. The photographer is so preoccupied with the baby, the mother's head has been cropped.*

mother cropping are probably intuitive; the baby is, after all, the paramount subject and the center of attention.

The rather more pragmatic reason why there are so many mother and child snapshots is that the father takes most of them; he can't be in and out of the frame at the same time. But on those occasions when he does get into the act, we notice that men hold babies in quite a different way than women do. Confidence is replaced by awkwardness (135) and the overreaction of a person handling a priceless piece of porcelain (136). In fact, if you look at the snapshot of the man

134. *Snapshot. American. 1942. A fairly common example of the "motherless child" snapshot. The framing of the baby and the exclusion of the mother may not be a simple case of ineptness; it could be intuitive.*

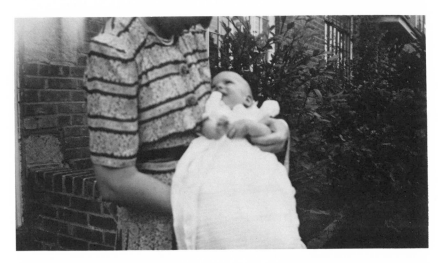

135. *Snapshot. Toned print. American. 1924. Men tend to hold babies in quite a different way than women: awkwardly and with a minimum of body contact. Here the father, rather than the baby, is being coaxed by somebody out of the shot.*

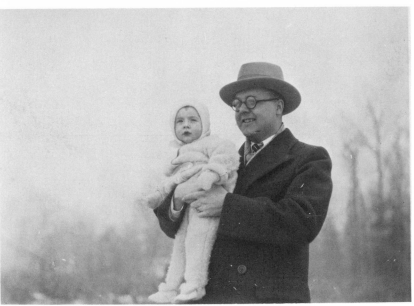

holding a dog (138), you may notice that the hold and the expression on the man's face are curiously similar to those of the fathers holding their babies. Generally there is a lack of close body contact with the baby who can often be observed being held at a distance as though it were a ticking bomb. Men apparently don't care to be caught caressing babies and to avoid this may adopt the "macho hold" (137) by hoisting the child on to their shoulder, to the consternation of all concerned.

136. *Snapshot. American. c.1935. The father holds the child gingerly and is more interested in "making a picture" than responding naturally to the child.*

137. *Snapshot. English. c.1935. To avoid any suggestion of effeminacy, men will often adopt a "macho" pose with a baby.*

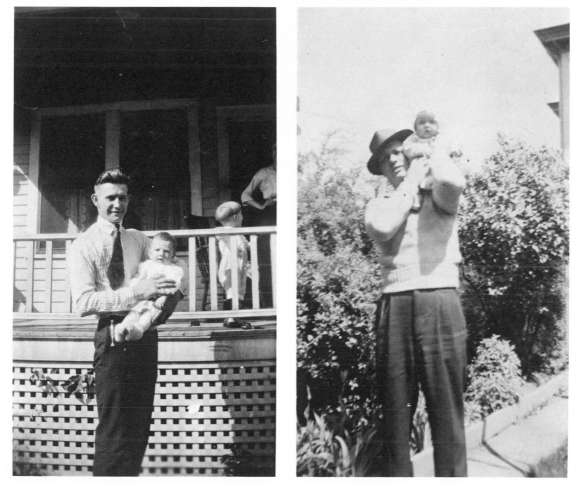

138. *Snapshot. Sepia-toned print. English. c.1920. If this man were holding a baby and not a dog, the hold and the pose would be about the same.*

139. *Snapshots. Kodacolor prints. American. 1960s. Every photograph contains ambiguities, but this pair is a conundrum. Same baby, same occasion—but who is the mother and who is the father? A test of observation and intuition.*

140. *Snapshot. Kodacolor print. American. 1982. Improved cameras, faster color film, and flash introduced a new photographic baby boom in the 1970s. Although this baby picture appears to be a far cry from the classic Madonna and Child pose, essential symbols persist. The tuxedo has merely replaced the embroidered gown and the empty champagne bottle aptly expresses parental joy at the child's arrival. Childhood innocence, as you can readily observe, remains a constant.*

7

❧⸿❧

Snapshots as Documents

How to "Read" Snapshots

Cᴀɴ ᴀɴ ᴀɴᴏɴʏᴍᴏᴜs sɴᴀᴘsʜᴏᴛ, which visually records information about a person, a place, a family, or a group, be considered as a "documentary" photograph?

Logic suggests that it cannot. The value of a documentary photograph rests entirely on the fact that all the details in it are explainable and identifiable. Once ambiguity creeps in, its function as a true record diminishes. A documentary photograph must be viewed in the context of its subject, the time, the circumstances, and the reasons for its existence. Take this context away and the photograph can become meaningless, even false, which of course is a negation of what documentary or journalistic photography is about.

This is a mistake made by museums that ask us to view documentary photographs as mere photographic images for their aesthetic value. A classic case of this misguided practice occurred with the exhibition of the work of Erich Salomon at the International Center of Photography in New York in 1982.

Generally regarded as the "father" of photojournalism, Salomon's *oeuvre*, at least that for which he is famous, consists of a unique pictorial record of Germany between the wars, mostly of behind-

141. *Snapshot. American. 1930s. Potentially interesting from a documentary standpoint, this snapshot of a milkman making his morning round ultimately fails through lack of precise information. Where was it taken? When? Why?*

closed-door meetings of formally attired statesmen who were, at that time, juggling the future of Europe between their port and cigars.

Salomon's view of those momentous years was not of book burnings, Jew-baiting, military parades, or any of the other horrifying manifestations of Nazism, but an extremely oblique one. None of his images mean much without extensive background information and, indeed, as magazine illustrations—their original purpose—they were extensively captioned.

The exhibition, however, deftly dislocated Salomon's photographs from their meaning and real significance. Viewers were directed to look upon the images as great works of art which conveyed "universal

142. *Erich Salomon. Statesmen at the Hague. German. 1930. Salomon, re-
garded as the father of modern photojournalism, was one of the first of his kind to
use a "candid camera". But his photographs generally require detailed captions to
fulfill their documentary purpose.*

truths" and were told that Salomon wasn't so much a photojournalist
as a great artist. The fact somehow escaped the organizers of the show
that, had viewers been provided with translations of the original cap-
tions, they could have gained new insights into one of the most
cataclysmic periods in history.

I give this example to illustrate how a documentary photograph
should (and shouldn't!) be regarded. Of course one is free to make
aesthetic judgments about documentary photographs, but too often it
is like judging a cow with an anatomical diagram of a horse as a guide.
It will be rather more useful, at this point, to attempt to define what a
documentary photograph really *is* and is *not*—and the reliable rule of

thumb here is to regard *all* claims to documentary truth with suspicion. "The camera cannot lie," Harold Evans says in his study of photojournalism (*Pictures on a Page*, Heinemann, London, 1978), "but it can be an accessory to untruth."

Consider, for example, the Walker Evans photograph of sharecropper Bud Woods and his family, taken in 1936 in Alabama, which has recently come under question. One of the most famous documentary photographs ever taken, its steely objectivity proved too strong for *Fortune* magazine, which commissioned the sharecropper series but declined to print them. The desperate plight of the Woods family also, apparently, proved too much for Walker Evans; in addition to the burden of poverty and hopelessness, Woods suffered from skin cancer due to a lifetime under the hot sun. In the picture (143) we see the sharecropper sitting with his family on the front porch of their shack; around his neck is a bandanna, placed there at the request of the photographer to hide the patch of ravaged skin.

143. *Walker Evans. Bud Woods and Family. American. 1936. One of the most celebrated documentary photographs ever taken, it nevertheless shies away from total truth. Evans had a bandanna placed over the sharecropper's shoulder to hide an unsightly skin cancer.*

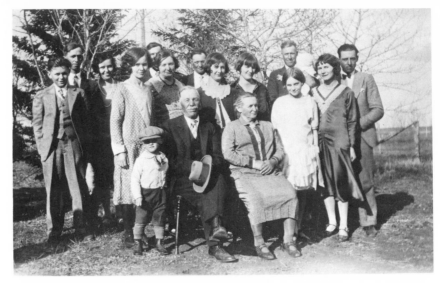

144. *Snapshot.*
Canadian. 1930s. A
marvelous dynastic study
rich in human diversity.
But as an anonymous
image it is useless as a
documentary record.

Another classic case of documentary ambivalence is that of the American photographer Edward S. Curtis, celebrated for his definitive twenty-volume record of the American Indian, begun in 1896 and completed in 1930. Now it seems that Curtis was as much a myth-maker as a documentarian. Research comparing his original negatives with the published photographs reveals that Curtis was a consistent bender of ethnological truth; he retouched and cropped prints and often supplied costumes and prop artifacts to assert the primitiveness of the Indian when in fact they were well on the way to being Western-ized. In two of his photographs, for instance, we can see the same feather headdress worn by the chiefs of two quite different tribes.

When documentary photographs possessing such immaculate ped-igrees can deceive, it's obvious that the anonymous snapshot, plucked from its context, must be evaluated with extra caution. We can never claim, with confidence, that we have interpreted its message or detail correctly, or know exactly what the visual information means. So it might be useful to look a little closer at the nature of the information that can be carried in the emulsion of a photograph and how we use it.

The invention of photography presented the world with a new, visual *lingua franca*. Today, photographs—reproduced in a variety of mediums—are about as much "read" as words. The photohistorians

Helmut and Alison Gernsheim somehow estimated that photography is responsible for 97 percent of our visual information, and while this may be arguable there is certainly a lot we don't appreciate about the effect of photographs on our perception of reality. And before we can analyze the enigmatic effect of a single snapshot it is vital that we examine the extent to which our lives are influenced by the entire range of photographic images.

Before photography, without photographic reference, the "real" was limited to the tangible, although an individual's conception of the world was in some measure influenced by his contact with literary and graphic imagery. But during at least the last 100 years, for the majority of us, our awareness of reality has been powerfully influenced by received photographic and related cinematic and video images. We are aware that our circumscribed lives offer us only a tiny part of the world to see and feel; for our view of the world at large, for our knowledge of the place we occupy in it, and even as evidence that what we do see and feel does in fact exist, we increasingly rely on two-dimensional duplicates. Such images have from childhood launched us on an extended, irreversible photo trip that won't end until we die. Whether an eventual take-over by instantaneous electronic images will erode the importance of static images in our lives remains to be seen, but for present generations, reality as we know it will still substantially be the

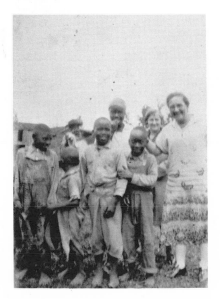

145. Snapshot. American. 1925. Stark visual evidence of the poverty and social status of blacks, but we don't know who they were or where they lived.

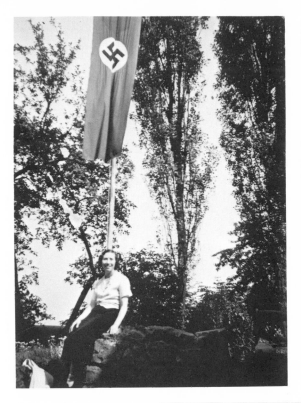

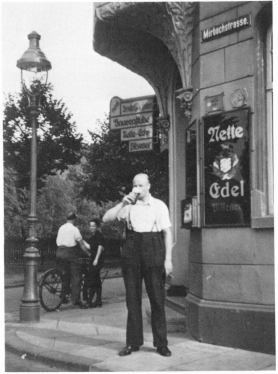

146. *Snapshots. English. 1936. These pictures are valuable as documents because they are from an album recording a summer holiday in the Rhineland in 1936. The woman laughing below the Nazi flag probably realized nothing of the cataclysm to come. But the snapshot of the group of surly Hitler Youth must certainly have prompted some fears for the future.*

by-product of the camera lens and photographic images will persist as extra threads in our environmental tapestry with the power to create new patterns of awareness.

Photographic images result in millions of people having fairly uniform visions of, for example, the summit of Mt. Everest, Greta Garbo, Auschwitz, or President Kennedy's assassination—graphic memories that are virtually ineradicable. But while photographic duplicates of the material world tend to propagate universal images—visual perceptions that are consistent among whole groups of people—this is not the case with our visions of the nonmaterial world. Our ideas of Heaven and Hell are unique and diverse and often stolen from such persuasive graphic visionaries as Michelangelo, Blake, and Doré. For our mental pictures of creatures from outer space we rely heavily on invented cinematic images. But if a human were able to bring back from beyond just one ordinary snapshot of Heaven or Hell or an angel, the images created by our imagination would melt instantly in the face of photographic truth. In this context it is interesting that almost every book published on the subject of UFOs contains a few photographs of the craft—as suspect as they are—to add credibility to several hundred pages of verbal argument.

On a more objective plane—that of serious biography—snapshots of the subject are being used less as incidental props and more as part of the biographical fabric. Of the hundred or more books written about Virginia Woolf in recent years—a veritable industry, amounting to millions of words—one, *A Marriage of True Minds* (Harcourt Brace Jovanovich, New York and London, 1977), gives a conspicuously more intimate and veracious portrait than most of the others, simply by its extensive selection of photos from the Woolfs' private snapshot albums.

The authority we grant to photographs is instinctive. We accept photographic evidence instantaneously from a very early age and become further convinced of inherent photographic truth as we proceed through life. But while we're aware that photographs can be deceitful we appear to do very little to train ourselves to "read" them with the same caution with which we approach the written word. This is particularly critical when we approach anonymous snapshots, which invariably lack useful information about who is in them and when, where, and why they were taken. If we intend to take snapshots seriously, we should expect to engage, at times, in some photo detection.

147. *Snapshots. English. 1928. Intuitively, you may guess that the boy in these photos is shy and withdrawn, perhaps dominated by the adults. Often such insights can be confirmed by body language; and the ability to read physical signs—clasped hands, positioning of limbs, eye contact, and so on—can help tease useful documentary information from photographs.*

We can, for example, learn to look for clues in human detail—idiosyncrasies of the face and body. Take the boy sitting in front of a group of adults in a garden (147). He sits there huddled in a reverie, remote from the adults. A second snapshot, taken later, shows him standing, and we note the tentative action of his right leg. A third photo shows him again avoiding the camera. He also has exceptionally large ears. We have enough signs, I think, to assume he has a shy, withdrawn personality.

Body language, though, is a slippery clue. It is more productive to develop a sharp eye for environmental detail. From the two snapshots in Plate 148, we can deduce that the boy and girl are the same, not from appearances, but from their surroundings. From clothing and other details we can tell that the photograph of them as young chil-

148. *Snapshots. American. 1930s. Environmental details establish that the boy and girl in these two photographs are the same, even though taken five or six years apart.*

dren was taken about 1930, and the other one some five or six years later.

Many snapshots are two-dimensional sources for documentary and historical information. The snapshot of the man standing by the U.S. Highway 36 sign in Kansas (149) was taken about 1930; it would be instructive to compare it with a photograph taken in the same spot half a century later. In such a situation of contrast and comparison the anonymous snapshot could be a valuable record.

In a similar vein the snapshots of the woman and girls in a suburban backyard (150), taken about 1915, yield interesting information about the style of living at that time. Despite the unkempt yard and the dilapidated fence, the family owned a bicycle, so they were not really poor by the standards of the time.

Just as potentially rich in information is the commonplace shot of the teenage boy in a living room (151). About the boy we know nothing, but as a record of suburban kitsch of the late 1960s—driftwood paneling, Naugahyde-covered, splay-legged furniture, primitive African wall plaques—the shot is a marvelously comprehensive document.

149. Snapshot. American. c. 1930. This snap contains enough information to give it documentary value, which would be further enhanced if it were compared with a photograph of the same highway half a century later.

150. *Snapshots. English. c.1915. Charming studies, these snapshots also reveal interesting information about home environments and living standards of the time.*

151. *Snapshot. Kodachrome. American. 1973. A revealing record of the interior furniture and decor fashionable in the late sixties.*

But these are fairly straightforward examples of documentary detection. Take the two snapshots of young ladies in Plate 152. Curiously, they came into my possession at different times and from different sources, yet it is clear both photographs were taken at the same location. Moreover, one of the young ladies appears in both shots. The women are all well groomed and elegantly and fashionably dressed. The older woman with the hat in the photo at right seems not old enough to be the mother of the girls but severe enough to be a teacher;

152. *Snapshots. Source unknown. c.1912. Nothing was known about this pair of anonymous pictures, but photo detection with a magnifying glass revealed some information. (See key drawing overpage).*

A. *The sapling in the vegetation at rear is the same; there appears to be no growth difference.*
B. *The clothing indicates both snapshots were taken between 1905 and 1915. The high lace collars on two of the young ladies were in vogue about 1910.*

 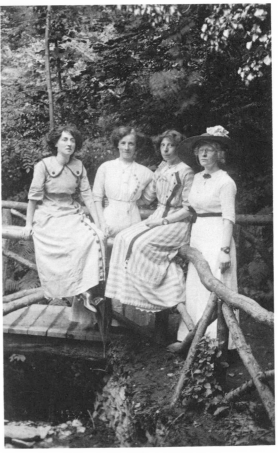

thus the girls might be college or university students. The pair of photographs challenged me and screamed for interpretation. Who were these young ladies? What was the connection between the two images? I had no way of answering the first question, but I attempted to tackle the second.

Systematically, I went over each snapshot with a magnifying glass. First, from the clothing I fixed the dates between 1905 and 1915. Then I noticed that two of the women wore wristwatches, larger but

C. *This young woman is the same in each photo.*
D. *The wristwatches on two of the women are nearly identical with some in a department store catalog of 1913.*
E. *The clump of plants indicates the photo at left was taken in mid- to late summer; that on the right in the spring.*
F. *This is confirmed by the post. In the left photo, it has a covering of bark which has shed off in the photo at right.*
G. *The prop indicates the photo at right was taken later.*

almost identical to some I found in a 1913 Gamages department store catalog (old catalogs are an excellent source for dating clothing and accessories). So I settled for about 1912.

Then I tried to find out which photograph was taken first. From the vegetation it appeared the one on the left was taken in mid- or late summer, the other in spring. The trunk of a tall sapling in the background looked the same in both photos—a clue, but not very helpful. Then I noticed the post supporting the rustic fence on the extreme right of each photograph. In the left-hand photo the post is covered with bark; in the other photo the bark has shed. So the first photo was taken in the summer of one year, while the second snapshot was taken the following year.

Despite my deductions, this pair of snapshots remains a puzzle, but at least I've had the satisfaction of discovering several connecting threads. And I'm sure that further study will yield more secrets.

Some sequences of anonymous snapshots, though, tell their stories with minimal speculation on the viewer's part. Some years back I picked up a packet of snapshots which appeared to be a record of an all male office fishing trip (153). Some cars in one of the photos fixed the date at around 1940. There were the usual stock shots of the catch but, at day's end, the sequence began to get really interesting.

The cards and the beer came out and the men played poker. The night wore on, but the keen photographer kept snapping, and progressively we see the participants dropping out, the victims of alcohol and fatigue. Perhaps one of them was the photographer who, forgetting to wind the film on, scored a double exposure. One man is asleep with a cigarette still in his mouth; another slumbers inside a large chest. But the classic shot, the last in the sequence, shows two of the men sound asleep in the same bed, one with his arm around the other—and keep in mind that this is 1940 and the occasion is a macho hunting trip. Whether the party caught any fish or not, this snapshot must have proved to be the prize catch of the trip.

153. *Snapshots. American. c. 1940. The first of a series of snapshots recording an all male fishing trip. They were taken by a keen photographer with a sense of humor, as demonstrated in the shot above.*

After a day's fishing, the men settle down to playing poker and drinking beer.

This double exposure may be an indication that the photographer was more interested in the beer than his camera work.

Under the influence of alcohol or fatigue or both, members of the party start to drop off to sleep.

Man is most *vulnerable when he's asleep, as this
snapshot cruelly testifies.*

Another *sleeping beauty. The subject is in for a sur-
prise when the photos are developed.*

But *few will be as surprised as these two when the
snapshots are handed around back at the office.*

8

❧

Appreciating the Snapshot

The Aesthetics of the Snapshot

Can a snapshot be a work of art? "Yes," according to top international photographer David Bailey in an ad for Olympus cameras, "when it is taken by Jacques-Henri Lartigue." Lartigue was the turn-of-the-century photographer whose snapshots of French life possess a style and elegance far beyond the capabilities of an amateur.

Less flippantly, though, can an amateur—more or less aiming a simple camera at a subject, clicking the shutter, and abandoning the result to the impersonal mechanics of mass processing—produce an image that can qualify as a "work of art"?

On the evidence before me, yes he can and frequently does. It is possible for an amateur, snapping a scene alongside a talented, experienced, professional photographer, to *accidentally* create an image that will almost certainly be different from but of equal or greater merit than that painstakingly produced by his skilled partner. This must be distressing to photographers, because we could certainly not say this about an amateur painter working alongside a professional artist.

Nevertheless, if in the future, as Andy Warhol once tantalizingly suggested, everyone will be famous for fifteen minutes, so, similarly, everyone taking snapshots could create a work of art once in a life-

time. A minor work, perhaps, but a work of art nonetheless, can be created in a click. And from the vast repository of trillions of snapshots already in existence there could be millions with the qualities we look for in a work of art. An eye and mind attuned to visual pleasures can identify and enjoy them.

Almost all snapshots are made with personal and documentary objectives foremost in mind, and we view our snapshots, and those of our family and friends, through this familiar frame. But, as we have seen, the rules change when we view anonymous snapshots. Now we have no personal connections; our eyes and mind are free to dispassionately respond to what we see. We can be attracted by striking compositions and juxtapositions; we can be intrigued by detail and ambiguity; we can be amused by visual ironies; we can be moved, disturbed, and perplexed. We can, in short, *experience* a work of art.

Don't be misled by the commonplace snapshot's ubiquity. Although previously dismissed as worthless, snapshots have, in the last decade, challenged the fundamental idea and criteria of conscious photographic creation as an art form.

The fact is that there are enough snapshots around that meet all the artistic requirements of critics to potentially subvert the entire structure of professional art photography. It is therefore no surprise that the photo establishment refuses to recognize that snapshots could be of aesthetic and critical importance. But to the discriminating collector of snapshots, able to assemble a portfolio of unique artworks almost for free, this disdain must be a source of delight.

The very suggestion that snapshots could be aesthetic objects continues to raise thoughtful eyebrows. Even I feel apologetic about it, especially as I've criticized the tendency to aestheticize journalistic photographs and have objected to transplanting images from their original contexts to suit today's curatorial and market demands. But to gain recognition, it seems the snapshot must fight its battle with the weapons chosen by photography's hierarchy.

The history of photography, unfortunately, has already been structured on the history of art, with its superstars and watershed works, all judged, of course, from the current aesthetic standpoint. Why a photograph was made, or how it was originally used, are values that are rarely considered. From the curatorial position, it has become the learned catalog's role to communicate to the public, not the photograph's. The museums and galleries have appointed themselves the

makers and keepers of photography's subjectively written history and its pedigree studbooks.

As I mentioned earlier, it's difficult for the photo establishment to take the snapshot seriously when it represents something that's uncontrollable. How can you pantheonize an anonymous snapshot? Identify it? Value it? And the superabundant snapshot would instantly reduce the photographic art market to rubble. But the fact that snapshots have no recognized aesthetic or market status need not deter us from enjoying them. On the contrary, we are in the marvelous position to play at being connoisseurs without paying exorbitantly for the pleasure!

Sometime in the future, snapshots may acquire their own standards and principles of appreciation, and will be judged only with other snapshots. In the meantime, however, while our sensibilities are being honed to respond to the snapshot, our appreciation must necessarily lean on traditional precepts and comparison with paintings and photographic antecedents in the established context of "photography as art."

One school of opinion sees photography as merely an extension of the pictorial art that emerged in the century or two before the invention of the camera. The increasingly representational way in which we recorded nature didn't pause or change, they claim, only the method by which it was recorded. Such historians regard photography as merely a technique within the modernist breakaway tradition. This point of view denies that, because cameras were better at the faithful representation of reality, photography drove painters to abstract art and all that followed. It ignores the fact that certain major artists were profoundly influenced by photographs and also the idea that photography has its own aesthetic syntax.

Such theories are, I believe, wrongheaded. But while many accept a relationship between painting and photography (they're two-dimensional, fixed-frame images, for a start), one must admit that the precise nature of the connection remains elusive. Cautious comparisons between snapshots and other photographs, photographs and paintings, and snapshots and paintings are therefore quite valid while this question persists. Comparison is, after all, a basic tool of the art historian, whose expertise rests on the ability to recognize significant similarities, differences, and relationships. In this way the evolution of human artistic expression over several millennia has been ordered.

One of the most important innovations in art was the advent of the Impressionists in the nineteenth century. They anticipated contemporary photographers by at least a century when they stole ideas from the snapshot. The artists included Delacroix, Courbet, Monet, and the most enthusiastic pirate of them all, Degas.

Their most conspicuous theft was the compositional amputation, the inadvertent cropping of the typical amateur photograph, a feature of Japanese wood-block engravings but hitherto unknown or not exploited by Western artists. The idea must have seemed more easily translatable from photographs, and Degas, Whistler, and Toulouse-Lautrec borrowed it to create visual shock in their paintings.

Degas, in fact, became an eager student of the "instantaneous photograph" as the snapshot was then called. His canvases of arrested motion, with dancers caught in gauche, transient poses in odd corners of his pictures, are pure translations of the snapshot style. But where the snapshot's unconventional composition was accidental, Degas's was carefully calculated, capturing the unexpected and preserving the tensions of figures caught off-balance. Degas, among others, also borrowed the "looming foreground figure" and the out-of-focus background which are features of so many snapshots. And there were other photographic eccentricities for the taking: blurring, halation effects, the fortuitous arrangement of people and details, and the results of technical accidents. The snapshot provided an exciting new source of imagery and technique to the artists, and in their turn the photographers appropriated the "soft focus" images of the Impressionists.

From that time on, artists and photographers have indulged in a mutual borrowing spree. The Impressionist movement helped to free art from the dark corner into which it had painted itself, and it also acted as a liberalizing spirit which bloomed and spread through all the graphic arts. The person who took the beautiful snapshot of the two girls in a yacht (154) may never have seen a Manet; nevertheless, he must have realized he had an excellent photograph according to the tastes of the time. The mood caught by this snapshot is remarkably similar to that in Manet's painting of twenty years earlier, *In the Boat* (155).

To take a recent example, the American artist Ben Shahn, who was also a skilled photographer, constantly used photographs from his huge files to supply details for his paintings. In this respect it is interesting to compare the three men in his painting, *Scotts Run, West*

154. *Snapshot. Albumen print. American. c.1895. An enchanting image, comparable in mood and spirit with Manet's* In the Boat.

155. *Edouard Manet.* In the Boat. *1874. Metropolitan Museum of Art, New York. Indirectly, many of Manet's Impressionist paintings paved the way for a more casual approach to outdoor photography.*

156. *Edgar Degas.*
Carriage at the Races.
*1872. Museum of Fine
Arts, Boston. The inad-
vertent cropping of
typical snapshots, also a
feature of Japanese
prints, was a device
Degas consistently used
in his paintings.*

157. *Edgar Degas.* At
the Milliner's. *Pastel on
paper. 1882. The Met-
ropolitan Museum of
Art, New York. Degas
was one of the most de-
voted "borrowers" of
snapshot idiosyncrasies,
in this case the obscuring
of relevant subject mat-
ter. Here, though, the
device is under control:
Degas has combined the
mirror and the assistant
as a single, self-evident
element.*

158. Snapshot. Toned print. American. 1920s. With highways, telegraph lines, and railroads disappearing into its wide horizons, the American landscape offered a natural outlet for the photographic appeal of compositions dominated by perspective. For amateurs it was simply a matter of setting distance at infinity for a viewable, and often striking, result.

159. Camille Pissarro. The Road to Versailles at Louveciennes. Oil on canvas. 1870. Sterling & Francine Clark Art Institute, Williamstown, Mass. The appeal of perspective shots had a source in the long tradition of landscape painting. Perspective views were enthusiastically exploited by the Impressionists.

160. Bill Morgan. Seventeenth Street Mansard. Oil painting. American. 1979. A contemporary example of borrowing from snapshot blunders—the accidental double exposure.

Virginia (162) with the snapshot of a group of men standing around in an English village (161). There is a striking similarity in the way all the men stand and look. Was this, one wonders, the result of Shahn's observation, or—more likely—a subtlety recorded by his camera? Many of Shahn's celebrated paintings can be related directly to his own photographs.

It never occurred to the naive snap shooter to borrow from artists or other photographers, but one can create an amusing and instructive game matching snapshots with the work of well-known professional

161. Snapshot. English. c.1920. This shot captures the characteristic way in which a group of men stand while idly chatting. Compare the men with those in the Shahn painting (163).

162. Ben Shahn. Scotts Run, West Virginia, 1937. *Collection of Whitney Museum of American Art, New York. Like many artists, Shahn used photographs to help him with details in his paintings. The attitudes of the men here are strikingly similar to those in the snapshot (162).*

photographers. The snapshot of two little girls in Plate 166 captures the same candid innocence in a typical study of children by Gertrude Käsebier (163). The facade of the clapboard house with its complex geometrics (165) is an anonymous snapshot; with minimal cropping it challenges a similar professional study by Philip Trager (166).

Searching to find amateur "double takes" of professional images may be fun and even educational, but it is hardly the way to go about learning to appreciate the appeal of snapshots. Certain images attract us; a person of sensibility will want to know why.

Apart from the subject matter itself, the composition of an image is probably the most important single element that attracts and holds the eye. Most of our ideas about composition derive from paintings; the artist, of course, having a free hand in the arrangement of his subject

163. *Gertrude Käsebier. Happy Days. American. 1902. Käsebier was one of the first photographers to introduce natural poses in studies of childhood, which gave much of her work the appearance of polished snapshots.*

164. Snapshot. English. c. 1935. Children have always been favorite subjects for the amateur camera, which captures the candid innocence of childhood with more ease and less pretense than the professional study.

matter. There is no reason why photographic composition should follow the same rules; snapshots, as we have learned, have helped to free us from many traditional, painterly conceptions about composition. Indeed, the essence of photographic composition may ultimately have more to do with meaning than with the disposition of graphic elements. Meanwhile, there are certain simple principles of composition that please our senses.

Take the lady with the sunshade in Plate 167. It is a tiny snapshot, 2½″ x 1½″, yet it reaches out to you because its compositional arrangement is one of opposing concentric curves, imparting a harmony pleasing to the eye.

The snapshot of the girl in a white dress (168) is also instantly attractive. Why? Probably because of the interplay of the strong per-

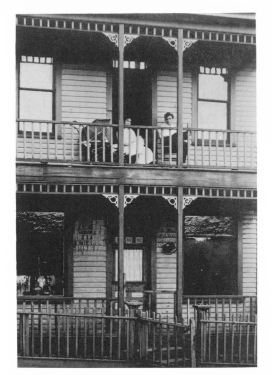

165. *Snapshot. American. c.1910. A wonderfully detailed clapboard facade and a fine composition as well. Compare it with the two professional shots of a similar subject.*

166. *Philip Trager.* House, Litchfield Avenue, Torrington, Connecticut, 1975. *The Witkin Gallery, New York.*

167. *Snapshot. American. c.1920. This image instantly engages our eye because of its harmonious composition of opposing concentric curves.*

168. *Snapshot. Albumen print. American. c.1895. The perspective angles and rhythmic triangular shapes give this picture a strong and pleasing unity.*

spective element and the rhythmic triangular shapes in the background. The eye is drawn in to a small area of action where the girl is buttoning her sleeve. Few professionals could have given this picture a stronger unity.

The young man framed in a doorway (169) engages our interest and has little difficulty holding it. His pose is bold and truculent, and that

169. *Snapshot. American. c. 1930. The challenging pose of the subject captures our initial attention, but the complementary pattern of lines and blocks of shadow holds it.*

certainly has something to do with it. But equally important are the interlocking lines and blocks of deep shadow around him, forming a pattern complementary to the figure.

The disposition of elements within the frame is a vital aspect of composition, capable of producing balance, tension, or shock. In this sense, Whistler was an elegant composer. Take for example his little 1865 seascape *Courbet at Trouville* (170). There are just three elements in the frame: the standing figure, a distant yacht, and the horizon. Yet he has achieved an electric serenity, if you can accept my contradiction, simply by placement.

170. *James McNeill Whistler.* Courbet at Trouville. Oil. *1865. Isabella Stuart Gardner Museum, Boston. The perfect balance of just three elements: the man's figure, the yacht, and the horizon. A serene composition achieved by perfect placement.*

We have all seen snapshot shockers like the one in Plate 171, with vast areas of the image occupied by nothing at all of significance. But if we forget our conventional notions of what a good picture of a subject like this should look like, it is quite an interesting image after all.

The young boy kneeling on the beach at the water's edge (172) is a similar image, with the figure unaccountably squashed into a corner while the rest of the frame is filled with an expanse of sea. Yet it works well; the accidental placement is beguiling visually, and there is a logic about showing all that sand and water. Isn't that what the sea is about—space?

The snapshot of the young woman in Plate 173 is the kind that hardly rates a second glance. But if we do happen to glance again we might find ourselves lingering over the woman's body. The composition is such that we have little alternative, but what probably interests us is how the woman's sexuality has been accentuated by the shadows on her dress. What's more, her face is in shadow, and this adds a touch

171. *Snapshot. American. 1942. A typically naive snapshot composition, but not without merit. It reminds us, for instance, that the equine environment is wide open space.*

172. *Snapshot. English. c.1955. Again, accidental capricious framing results in an offbeat though pleasing composition. And logical, too—the sea is also about space.*

173. *Snapshot. American. c.1944. The hard angles of the house contrast with the soft form of the woman, whose sexuality is further emphasized by body and facial shadows.*

of mystery. All this was accidental, of course, but a painter might aim for these same touches of emphasis.

A rather less static compositional device is that of creating imbalance and tension. The snapshot of the large lady (174) on a jetty achieves this perfectly; she looms, she leans, and, contrary to our expectations, she almost floats, and this disturbs us. A similar example, although accomplished in a different way, is the picture of two children running in a backyard (175). Our interest is first captured by the combination of perspective lines running through three receding planes: the baby with the ball, the young boy, and the mother in the doorway. The two children are caught in motion, running toward us, and even though we can't see the face of the nearest child, it doesn't matter; the three connected figures create a tension that gets us involved.

The quality of tension achieved by movement is very photographic; freezing motion is something most cameras can do at will. By this I do not necessarily mean frozen images of people engaged in some violent physical activity like running or jumping, but rather the camera's ability to "stop time," to preserve a moment.

Many snapshots of people will elicit a remark like, "Isn't it terrific the way he's caught her smile!" By the law of averages, many snap-

174. *Snapshot. Sepia-tone print. American. c. 1895. The looming figure of the woman dominates the men in the boat, and her body, thrust forward and off-balance (not unlike a ship's figurehead) creates tensions which disturb and intrigue us.*

175. *Snapshot. English. 1940s. An exceptionally interesting and complex composition resulting from the planes created by the three receding figures and the strong perspective angles.*

shots unintentionally capture such a moment—a fleeting instant that seems so magically right for the subject. It is one of the most elusive and sought after of all photographic qualities. One photographer who exemplifies the quest for this magic moment is Henri Cartier-Bresson, who called it the "decisive moment."

176. Snapshot. American. c. 1895. By the end of the nineteenth century, cameras and films were fast enough to freeze motion like this, adding another dimension to photography.

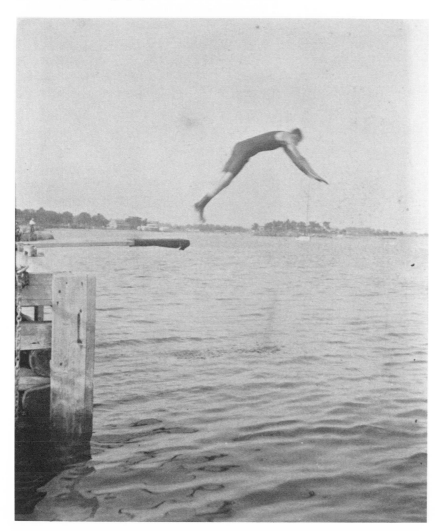

177. Snapshot. American. c. 1910. A less obvious example of frozen action, more an example of a "captured moment." The resultant tension involves us and invites conjecture.

Cartier-Bresson's theory of the decisive moment is especially appealing. It helps explain the often unexplainable: why some photographic images attract us more than others and why some photographers are more consistently successful than others. They intuitively (or, with amateurs, accidentally) recognize an order—of rhythm, pattern, and movement—that is in equilibrium the moment they click the shutter. This is, Cartier-Bresson explains, the decisive moment. Other photo theorists have since added that it is also the moment when "the subject gives up its secrets." To critic John Berger, photography derives from a play with time: "The choice is not between photographing x and y; but between photographing at x moment and y moment."

178. *Henri Cartier-Bresson. Behind St. Lazare, Paris. 1932. A photographic illustration of Cartier-Bresson's "decisive moment."*

The Cartier-Bresson photographs, *Behind St. Lazare, Paris* (178), and *Madrid, Spain, 1933* (179), illustrate this brilliantly: decisive moments in time. They are projected with such force that we cannot visualize these quite ordinary scenes in any other way. Justly, they are two of the master's most celebrated images.

179. *Henri-Cartier-Bresson.* Madrid, Spain, 1933. *The moment is so right that it is difficult to visualize this scene in any other way. It has the quality of absolute authority.*

But now see what an amateur can do (180). It is an equally commonplace scene, but the moment is just as magical. The man looks to the camera—there's our connection, as viewers. The man is linked to the boy by their motion in the same direction and also visually by the tree's shadow. The man and boy are in a state of what someone has called "relaxed tension," poised fleetingly on a country track in a sliver of time to burn their image on our consciousness. This is one of my favorite snapshots.

There are other characteristics of photographs and snapshots that are more evasive, less definable. The picture of the man and woman in Plate 182 is a little marvel, concentrating and crystalizing in a single image all the essential symbolism of the Roaring Twenties. The snap-

180. *Snapshot. American. c. 1940. An amateur example of the "decisive moment." The man looks to the camera, providing a connection with the viewer. The same direction of movement and the tree shadow connect the man to the boy—a link pregnant with visual tensions. An excellent example of how the commonplace can captivate.*

181. *Snapshot. American. 1920s. A "decisive moment" photograph in which the out-of-frame gaze of the two men further intrigues us.*

182. Snapshot. American. c.1925. The aloof expressions, the confident pose, the shape and texture of the clothing, the vintage car in the background, all contribute to a unified image that summarizes the look of the 1920s.

shot of the young woman in Plate 183 not only fixes a period but also a symbolic face—the quintessential all-American girl we know we've seen somewhere else. This was the kind of idealized face you saw in Coca-Cola ads during the 1940s.

With snapshots, the distance between the commonplace and the surreal isn't so great. Out of their context many snapshots assume bizarre, surreal, and mysterious qualities. The little girl with her beribboned pet lamb (184); the baby inexplicably pointing to a distant telegraph pole (185); the playing card ladies (186)—all these, to the persons in them and to the people who knew them, were merely ordinary snapshots. But removed from their indigenous contexts they

183. *Snapshot. American. c. 1945. If this face strikes a chord, it may be because it resembles the stereotyped all-American girl of the 1940s who smiled at us from Coca-Cola ads and billboards. A case of nature imitating art?*

184. *Snapshot. American. 1909. A charming, homely snapshot; but out of the context of the family album this image acquires overtones of mystery, of the surreal.*

185. *Snapshot. Toned print. American. c. 1905. A delightful, tender study of a child. But as an anonymous photograph it becomes a rather cryptic image of a child pointing to a distant telegraph pole.*

186. *Snapshot. English. c. 1920. To the people in it, this snapshot was doubtless a memento of some special occasion. In an anonymous context, though, it is a distinctly bizarre and unexplainable image, inviting our imagination to take flight.*

evoke in each of us differing responses, perhaps according to how the image echoes in our subconscious.

Pairs and series of anonymous snapshots can intrigue us in much the same way, without our knowing why. The two photographs of four different people (187) is a good example, forcing us to ask the question invited by photographic ambiguity: "What's happening here?"

187. Snapshots. English. c. 1925. A sequence of photographs can introduce a mysterious and surreal element absent in the individual images. Here the two superficially similar but actually quite different snapshots provoke a stream of questions. Why have the expressions changed from one photo to the other? Why has one woman changed places, and why has the second woman's place been taken by another?

Which brings us back, perhaps inevitably, to the subject matter of the snapshot. The late French critic and philosopher Roland Barthes concluded that a photograph can never, no matter what, sever its umbilical cord with its subject, or referent, as he termed it. Our response to viewing any photograph, he believed, centered on two properties—its *studium* and its *punctum*, the studium supplying the information you expected to get from the image, while the punctum was the source of a range of personal and sometimes profound reactions.

Barthes's conclusion represents the antiaesthetic view of photography, and it's useful to keep it in mind when we fall in love with some seemingly quite ordinary snapshot, the reason for our attraction being something that will always elude us. I have pondered over the snapshot of the two women with the baby (188) for several years. Com-

188. *Snapshot. American. c. 1940s. Some snapshots appeal to us, yet resist analysis. Perhaps, in such cases, the images evoke echoes deep within our subconscious.*

positionally, and in just about every other way, it's a mess. The little boy is holding a framed photograph; is that the element that's sending out such mesmerizing vibes to me? Is it the image's simple honesty? The patterns in the foliage?

Knowing the answer is not, in the final analysis, of do or die importance. What does matter is that we should surrender ourselves to the contemplation of such images. Contemplation is an appreciative way of responding to a photograph, and linking the unknown photographer, the image, and *you*—completing the triangle—can be a most rewarding, creative act.

9

❦

Snapshot Chic

How Contemporary Photography
Snapped up the Snapshot

THESE DAYS, with art galleries exhibiting soiled diapers; with critics defending the aesthetic merit of a stack of bricks; with artists themselves nakedly cavorting around covered in paint, it takes a lot to outrage the art world. But an exhibition in New York's Museum of Modern Art in 1976 proved that art critics are still shockable.

The real surprise, however, was the modest nature of the offending display. What so agitated the art establishment was a collection of photographs by William Eggleston. From the point of view of an innocent visitor, the photographs appeared to be nothing more than inept, amateur snapshots, with all the faults of the genre: banal subject matter, tilted horizons, cluttered backgrounds, and compositions guaranteed to set the teeth on edge. One print showed a corrugated iron fence with a foreground of weeds. Others were dim, noncommittal portraits. The *pièce de résistance* was the view of a bare light bulb hanging below a red-painted ceiling. Viewed as a whole the photographs, so clumsy, so naive, so purposeless, appeared to express no point of view at all. And not by any stretch of the imagination could even the slightest whiff of revolutionary cordite be detected in the air. Yet here they were, these inexplicable images, accorded a major showing in the world's most respected repository of contemporary art, with all that it implied.

What so upset lovers of fine photography was that everything that had been learned about the medium over nearly a century and a half appeared to have been tossed to the dogs. It was photo nihilism! Worse, the images so admired by the Museum of Modern Art encompassed most of the artistic faults one finds in the *worst* examples of family snapshots. "These pictures," complained a leading New York critic, "belong to the world of snapshot chic . . . that is now the rage among many young photographers." Another objector wrote amusingly, "But mommy, the emperor has no clothes on." "Hush, dear, MOMA knows best. You're not old enough or sensitive enough to see the beautiful shape of his robes and the exquisite jeweled colors." "But, mommy, he's naked. There's *nothing* at all." "Quiet! The prime minister himself approved of Mr. Eggleston's work . . . can't you hear the crowd cheering?" "But mommy . . ."

The furor sparked off by these images had been building for a long time, for Eggleston's punk pictures were not the first of their kind to attract notoriety. In 1970, Lee Friedlander, a fellow American, exhibited a collection of ordinary small-town street scenes featuring blurred impressions of vehicles and passersby and numbingly dull vistas he seemed to have taken at random with his eyes closed. Close on his heels followed others: Emmet Gowin, whose posed group shots could have been plucked from any family album; Stephen Shore's crude and insipidly colored postcard photos of the most nondescript kind; and Mark Cohen's outrageously cropped prints of people minus their heads and feet. And these were only the vanguard of other earnest photographers who had apparently flung away their Nikons and Leicas to produce instead images that looked as though they'd been made by toy plastic cameras.

Some actually did. Ohio photographer Nancy Rexroth's approach to synthesizing snapshots was to buy a $1.50 toy *Diana* camera, guaranteeing defective images. "The *Diana* is made for feelings," she subsequently wrote. "The *Diana* images are often like something you might faintly see in the background of a photograph. Strange fuzzy leaves, masses and forms, simplified doorways. Sometimes I feel as though I could step over the edge of the frame and walk backwards into this unknown region."

By 1978 this burgeoning school of professional snappists had been labeled variously the "New Wave," "New Photography," and "Snapshot Chic." Its defenders claimed their pictures were significant because they "expand our sense of photographic tradition" and because

they challenged conventional artistic standards. The New Photographers, they maintained, were doing what the earlier abstract painters did, which was to reject subject matter and visual content in favor of exploring pure photographic form. Or, in the simpler words of the late Garry Winogrand, one of the movement's leading practitioners, "I don't have anything to say in any picture . . . I photograph to find out what something will look like when photographed."

Almost miraculously, contemporary photography found new heroes. "If Robert Frank is the Cézanne of the new formalism in photography," wrote New York critic Gene Thornton, "and if Winogrand and Friedlander are its Van Gogh and Gauguin, we have to conclude that Eggleston is photography's Matisse, Kandinsky, and Mondrian all rolled into one, its great liberator from order, purpose, meaning, nature, art, and everything else that has conspired to keep photography from being truly itself."

This seems a rather overpowering testimonial, but one cannot ignore the analogy with the breakaway nonrepresentational artists at the beginning of this century. One can imagine, during the political, cultural, and social ferment of the 1960s, the dilemma of an ambitious, creative photographer: "Can I compete with Steiglitz, Strand, and Weston? Do I want to? Are their styles relevant today? What's the point?"

Just as Picasso, Braque, Matisse, and other artists found their inspiration in pure forms such as primitive African sculpture, so the New Photographers found theirs in the uncorrupted snapshot. Just as African carvings owed nothing to the developed traditions of Western art, snapshots owed nothing to the traditions of "aesthetic" photography. The snapshot idiom provided a fresh graphic and philosophical foundation for exploration and experiment and ultimately a means to reorganize and manipulate subject matter without abandoning photography's relationship with reality. As Janet Malcolm put it, "Photography went modernist not, as has been supposed, when it began to imitate modern abstract art but when it began to study snapshots." And the New Photographers, she continued, poked their cameras into the most pedestrian of human activities, "with nothing in mind, with none of the elaborate previsualizations of traditional art photography," and "repeatedly clicked the shutters of their small cameras. Later, scanning contact sheets, they selected their pictures—decided what the decisive moment had been."

Yet, historically, the origins of the New Photography are far from clear-cut. Robert Frank is usually credited with not only rediscovering America in the collection of eighty or so photographs published in 1959 called *The Americans*, but also for inventing the "snapshot aesthetic," with "a new method of description." According to Janet Malcolm, Frank permitted the camera "what no art photographer had ever hitherto let it get away with—all the accidents of light, the messy conjunctions of shape, the randomness of the framing, the disorderliness of the composition, the arbitrariness of gesture and expression, the blurriness and graininess of the printing." This certainly sounds like a description of someone simply deciding to imitate snapshots.

But it seems likely that Frank's inspiration drew from a more sophisticated and respectable source. You'll find all the banality of subject matter, the dispassionate frontal views, the tilted frames and ambiguities in many of the 1930s FSA (Farm Security Administration) photographs of Walker Evans, an admired documentarian. His camera was not artistically, but intellectually, directed. His aim, in a photograph, was to transcend its subject. In Evans's *oeuvre*, especially, we typically appreciate an image without quite knowing how it achieves its effect. Whether Evans respected the special qualities of snapshots we don't know, but he patently had nothing against them.

Whatever the origins of the New Photography, they are neither necessarily profound nor complex. From one viewpoint, all that has been achieved is a transformation of the vernacular characteristics of the snapshot into artistic style. Thus the Jacot portrait of Giacometti (189) adapts the not untypical snapshot mistake of positioning the subject too near the bottom of the frame, but gives it real style and meaning by filling in the rest of the space with a distinctive Giacometti sculpture; the man and his work are linked in a logical manner. Similarly John Wall's *Mowing the Lawn* (190) borrows the common snapshot error of obscuring the subject. But here the unobstructed woman's face would have been irrelevant, even distracting; what the photographer set out to do was to portray a slice of ordinary British life, and he achieves this handsomely.

It would be inaccurate, though, to claim that professional imitation has an artistic style totally divorced from the vernacular original. You could say, on the contrary, that every example of New Photography has its snapshot twin. Take Henry Wessel, Jr.'s photograph of suburban houses, now in the Museum of Modern Art (191). More than an

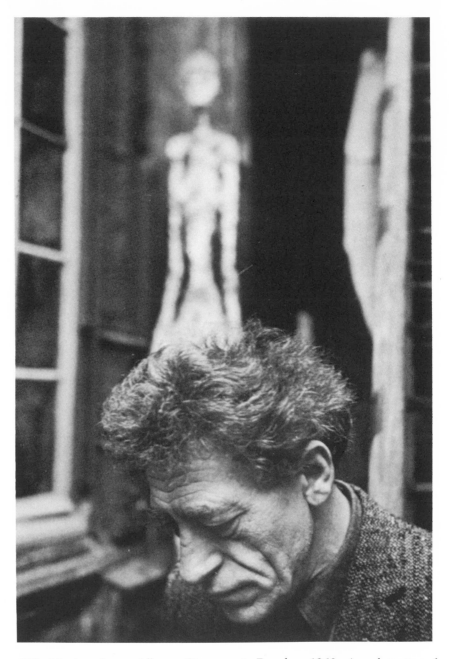

189. *Monique Jacot. Alberto Giacometti. French. c.1960. An adaptation of the snapshot's wayward framing, but given style and meaning by linking the detailed closeup of the sculptor with a typical example of his work as a backdrop.*

190. *John Wall.* Mowing the Lawn. *British. 1974. The common snapshot error of obscuring the subject turned to advantage. The photographer set out to portay a fragment of ordinary British life, and in this case the unobstructed woman's face would have proved distracting.*

echo of the snapshot idiom, it is undoubtedly a noteworthy image. But doesn't the anonymous snapshot of a suburban house (192) capture the essential blandness and ordinariness of suburbia with equal wit and force? In fact, because it is a less dramatic composition, it is an even more truthful representation of its commonplace subject.

The professional and artist photographers, of course, possess equipment and expertise that the family photographer doesn't. Their large format cameras are capable of great and sensuous detail. From two or three rolls of film they will select a single image that meets all their requirements. Then follows painstaking printing, retouching, cropping, and mounting. All this can deceive us, but a snapshot still may

191. Henry Wessel, Jr. Untitled. American. 1972. Museum of Modern Art, New York. A New Wave version of a snapshot, underpinned by a well-controlled unity.

192. Snapshot. American. 1940s. Compared with the professional version, the genuine snapshot is a less vivid composition, but because of this more effectively captures the essential blandness of its commonplace subject.

contain all the really essential elements of its professional counterpart if you disengage yourself from technical considerations.

So far, we've considered only cautious professional flirtations with the snapshot idiom. What is really extraordinary about the Snapshot Chic school is its obsession with exploring every snapshot aberration to the bitter end. How else, for example, to explain much of Garry Winogrand's work, with its vapid subject matter, topsy-turvy horizons, littered foregrounds, and general obfuscation? Interestingly, Edward Steichen, when Director of Photography at the Museum of Modern Art, called Winogrand's images "dangerously close to snapshots," but purchased a batch of them just the same.

Other practitioners have dug even deeper into the snapshot's ragbag of shortcomings. The lopped-off heads we often see in family albums have been appropriated by Andre Gelpke (194). The rear-view shots of people, which for some reason seem to appeal to the amateur (195, 196), are also popular with the chic school; in 1975 Marcia Resnick obtained a government grant to publish her collection of photographs entitled *See*, in which every image is of a person's back (197).

193. *Snapshot. Polaroid. American. 1980. A clear-cut case of accidental decapitation.*

194. *Andre Gelpke. Plastic People. German. 1979. Here the decapitation is not the viewfinder's fault, but deliberate, perhaps to illustate the mindlessness of social occasions such as this. The picture could have been aptly titled "Faceless People."*

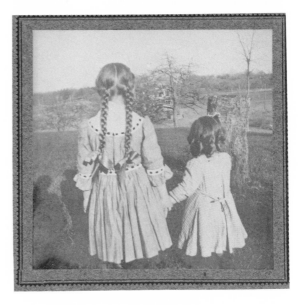

195. *Snapshot. Toned print. American. 1911. This angle was chosen by the photographer to show off the children's hair.*

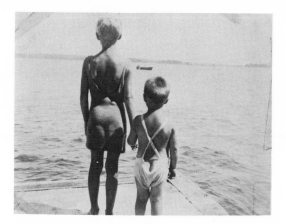

196. *Snapshot. American. c. 1930. Back views of people are surprisingly common in the snapshot genre.*

197. *Marcia Resnick. American. 1975. A typical print from a collection of photographs entitled* See, *consisting entirely of the backs of subjects.*

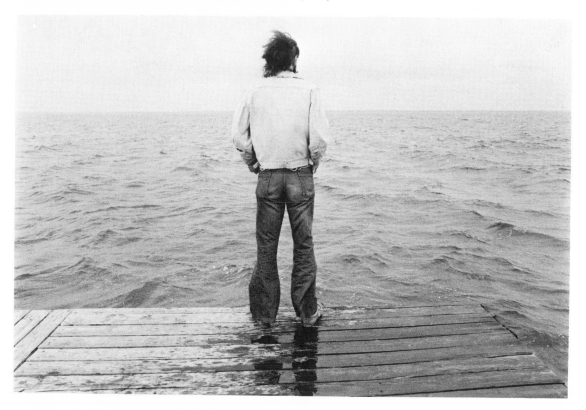

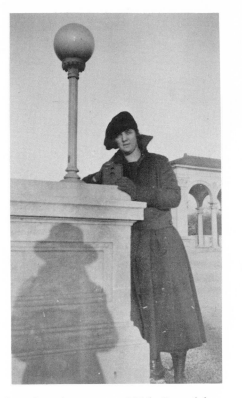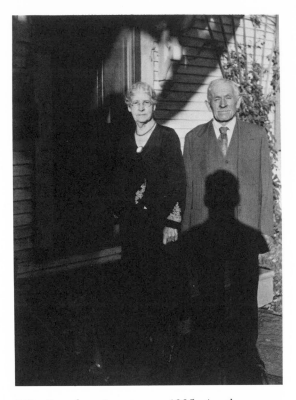

198. *Snapshot. American. c. 1935. One of the most ubiquitous snapshot* faux pas—*the shadow of the photographer intruding into the picture area.*

199. *Snapshot. American. c. 1935. Another example of the photographer's intrusive calling card.*

Few family albums are without at least one snapshot in which the shadow of the photographer intrudes into the picture. This hallmark, too, has been avidly picked up by the professionals, not only because of the naive touch it adds, but also because it serves as a symbolic link with the photographer. Such theorizing is fine but not infrequently it can be unintentionally counterproductive. Thus, commenting on a 1978 Lee Friedlander exhibition, New York photography critic Ben Lifson wrote (with the photograph shown in Plate 201 in mind, showing the photographer's shadow cast on the back of a blond woman in a New York street) that Friedlander's work projected "public images of private lust." The phrase had far more power than the contrived, matter-of-fact print that inspired it.

This, however, is not to denigrate Friedlander's fecund originality

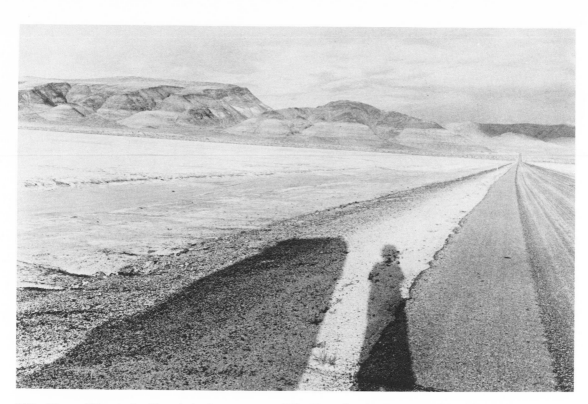

200. Henry Wessel, Jr. Untitled. American. c.1973. Here the photographer's shadow is intentionally cast into the picture frame, presumably to serve as a symbolic link between the photographer and his image.

201. Lee Friedlander. New York, 1966. American. In this shot, the photographer's shadow dominates the picture. Of this print, and others like it, critic Ben Lifson intriguingly suggested that they projected "public images of private lust."

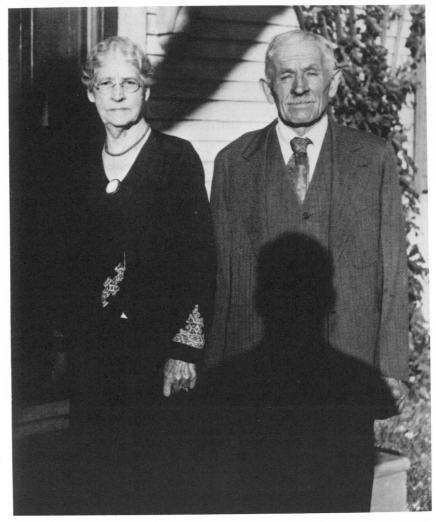

202. Snapshot, enlarged and cropped. When enlarged, the picture in Plate 199 revealed the faces of two strong, captivating personalities. Some minimal cropping of extraneous detail gave the print an authoritative quality that would not be out of place on any gallery wall.

nor the remorseless dedication with which he has pursued and adapted the qualities of the snapshot; his images are arresting and ingenious and often have the shock value of a cold shower. But has he really shown us anything that cannot be found in anonymous snaps? Take for example a snapshot I found in a flea market shoebox of an elderly Chicago couple, c.1935 (199), at first glance nothing but a run-of-the-mill image with a well-defined shadow of the photographer thrown against the subjects. Copied and enlarged (202) to enhance the detail, the couple emerge as interesting, forthright personalities,

to whom the camera's intrusion was but a brief nuisance in their lives. When modestly cropped, the print acquired an authoritative quality that would not be out of place on any gallery wall.

Amateurs seem to find it difficult to discard imperfect snapshots, including outright duds, so it's hardly surprising to find that even damaged snapshots have provided a source of inspiration for the New Photography. Thomas Barrow, for instance, takes photographs and then partly obliterates the prints with unsightly cancellation crosses (203). Nor is the assumed banality of family snapshots ignored. Mark Cohen's obsession is with the aimless and the mundane. He stares at the object—soda bottles, a baby, a high school football team, a rose—

203. *Thomas F. Barrow.* Tucson Palm. *Silver print. American. 1975. Even worthless and damaged snapshots have provided a source of inspiration for professionals.*

204. Snapshot. English. 1970. This is supposed to show Figaro, a pet cat, looking at some ducks in a stream below. It personifies the obscurantism common in snapshots, caused by faulty focusing and movement.

with such concentrated rapture that he hallucinates and, like those hallucinogen-induced images of the 1960s, the resulting prints are masterpieces of visual boredom.

The obscurantism common in the snapshot idiom—off-focus and blurred shots—would seem to be the one element that contemporary photographers would shun. Figaro the pet cat (204) is a representative example. On the contrary, for the chic school, obscurantism translates to mystery. But far from being enigmatic, a good many of their images are simply unfathomable.

In this area the high priest of high chic is surely Ralph Meatyard, a Kentucky optician who took up photography in the mid-1950s, exhibiting widely, and picking up a trickle of critical notices which, a few years before his death in 1972, became a flood of adulatory reviews, articles, and monographs. One was entitled *The Strange World of Ralph Eugene Meatyard*, but although his images were strange they were hardly new, being based almost exclusively on the most extreme of snapshot aberrations: blurred movement, double exposures (with just that slight out-of-register effect that makes you wonder if your eyes are acting up), banal subject matter typically obscured in deep shadow, and an obsessive ambiguity (205). Although artfully contrived to appear artless, there is something undeniably haunting in Meatyard's photographs; what is unacknowledged, though, is his huge debt to the snapshot idiom.

But even as the snapshot's barrel of quirks is being scraped clean by enthusiastic imitators, along comes instant photography with an entirely new repertoire of abnormalities. As anyone who has had a film stick in a Polaroid camera knows, the result can be delightfully bizarre when it is finally fished out and allowed to develop. Pressure of any

205. Ralph Meatyard. Untitled. American. c.1972. Contrived obscurantism achieved by off-focus and double exposure. The resulting image is enigmatic or unfathomable, according to your point of view.

kind on the self-developing emulsion layers affects the image (206), and this property has been exploited in a spectacular way by Lucas Samaras, the Greek-born American photographer. By scraping, rubbing, and teasing the emulsion surface during the several seconds it takes to develop, Samaras has produced a wide range of interesting effects (207), which he calls "photo-transformations" and which crit-

206. *Snapshots. Color Polaroids. American. 1980. Characteristic effects caused by undeveloped prints jamming in the camera. Any pressure on the pigment layers during developing results in a wide and spectacular range of distortions.*

207. *Lucas Samaras. Photo-Transformation, 2/14/74. Color Polaroid. American. The Pace Gallery, New York. Samaras was one of the first professionals to exploit the manipulative properties of the Polaroid emulsion.*

ics have imaginatively likened to "painted marbelized grasshoppers."

That is my brief summary of the origins of the New Photography and what it is all about. Some may think it biased and unfair, perhaps because the work of its leading practitioners has been so entangled with overblown praise and critical rhetoric. If, on the one hand, photography is indeed having one of its healthiest shakeups in half a century, it has also, on the other hand, spawned a self-serving industry which makes down-to-earth inquiry seem like a seditious act.

The fact is that the humble snapshot, directly and indirectly, has helped to release photography from its Victorian corset. It has reminded us that pictures of ordinary people doing ordinary things can be profoundly interesting. It has added to, not subtracted from, photography's horizons.

What today's art snap shooters have achieved with their large-format cameras and high-tech optics gives us much the same view of the world as that presented by the lowly snapshot, but with the unnerving clarity that imparts authority. What the amateur camera misses, the expensive hardware captures effortlessly; the detail, the subtleties of tone, texture, and color that can be as visually seductive as lingerie. And their work, it must be said, has consistency and unity, compared to the amateurs' haphazard efforts.

In less than twenty years, the exponents of the New Photography have become, perhaps fleetingly, the academicians of today. That's a curious aspect of the emergence of the chic school: its speedy and gushing acceptance by the influential core of the photo establishment. No bunch of artistic radicals ever had it so easy. Doing first a double take and then a double U-turn, the establishment quickly smudged over the contradictory philosophical differences between "professional" snapshots and traditional art photography and proceeded on its merry way. With expert coxswainship the boat hardly rocked. The pantheon of modern painting took a good half century to construct and install with heroes; that of the New Photography, with its superworks and megastars, was whipped up in two decades.

But one wonders how substantial this edifice really is. Feeling slightly uneasy about its shaky foundations, the establishment has begun to reach out in search of a more concrete history. Trying to avoid being swamped by snapshots it has instead floundered into a quagmire, leading nowhere.

Consider the case of Joe Steinmetz. For forty-odd years beginning about 1939, Mr. Steinmetz was one of thousands of professional jour-

neyman photographers in America recording weddings, charity balls, bar mitzvahs, and other celebrations of ordinary life. His work merited no critical attention—indeed, no attention of any kind—until, around 1980, somebody noticed a similarity between his photographs and those of some of the leading New Wave photographers, Friedlander and Winogrand among them. The odd thing was, here was a body of images (or at least a few dozen selected from many thousands) which possessed all the heightened characteristics of the chic product—except that they were taken some forty years earlier. This, however, did not make chic photographs old-fashioned; on the contrary, Steinmetz's forty-year-old images were adjudged to be "truly modern and truly photographic." By a trick of logic, a sharp eye, and the enterprise of a publisher and various galleries, Joe Steinmetz is now part of the New Photography's heritage. It's fair to ask: "How many other Joe Steinmetzes are out there?"

This snapping at the heels, as it were, of snapshot chic, has been a wholly unwelcome development to its supporters. "The idea that the snapshot would be thought of as a cult or movement," commented Lee Friedlander, "is very tiresome to me and, I'm sure, confusing to others." Like rich boys ashamed of their poor mothers, many of the leading chic exponents have in fact become quite coy about the relation between their images and the humble snapshot; several of them refused outright to allow examples of their work to be included in this book when they learned of its subject matter. These are signs that the love affair is on the wane, or is at least a realization on the part of chic professionals that there is little point and no future in continuing to plagiarize the snapshot.

Innocence is the quintessence of the snapshot, wrote the American photographer and teacher Lisette Model: "The professional photographer, in spite of the instantaneous and spontaneous means at his disposal, can never achieve that degree of innocence. He may try to imitate the snapshot. He may wait on purpose for the loose, unconventional moment. The moment may be unstructured, but the photographer is not. He may make a masterpiece by selecting the moment but he can never make a snapshot."

But wherever contemporary photography chooses to go, the snapshot experience will not have been profitless. Many professionals have learned lessons from the family album but have applied them without the pretensions and archness of the chic school. The photojournalists, especially, have emerged triumphant on a horizon beyond mere snap-

shot techniques. To record fragments of life and experience, what more appropriate way than with fragmented compositions, blurrings, and ambiguous but telling irrelevancies? As a writer might use a subject's "street" language to describe that subject's life, so a photojournalist uses and extends the idiom of the family album to record, with a far more sympathetic focus, the lives of a family, or a group of people, or the life of a single person.

And, despite what has been said, compared to the best of the New Photography, much of contemporary museum and gallery photography is contrived and irrelevant. It hammers at those same confining walls from which, using the snapshot as their ladder, Friedlander, Winogrand, and the others escaped. But this particular getaway, refreshing as it has been, is only temporary, for all of them must know, deep in their artistic hearts, that their most prized image—the result of discipline, craftsmanship and technology—can also be created (and probably already has been) by any one of millions of snapshot amateurs sometime, somewhere, simply by sheer accident.

For answers, see footnote on following pages.

208. *Snapshot or imitation? These eight photographs are either anonymous snapshots or professional examples of "Snapshot Chic" photography. Can you guess which is which? All images have been reproduced in a common size, and the answers are given on p. 212.*

A

B

C

D

E

F

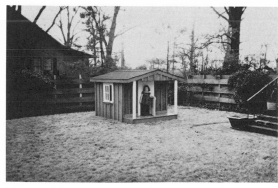

G

H

10

Snapshots as Art

Beyond the Family Album

Shortly after his arrival in New York in 1915, the French artist Marcel Duchamp selected several everyday objects—a comb, a hat rack, a typewriter cover, a urinal among them—and proclaimed them examples of "ready-made art."

To a public accustomed to the more conventional art forms and with only the slenderest acquaintance with Picasso and Braque, this daring departure took some swallowing. But, as Duchamp pointed out, art resides not only in an image or an object but also in the way we think about it. There was no God-given rule, in his view, that made it necessary to use paint or canvas or marble to make an aesthetic statement; such a statement might be made with virtually any object according to the intentions of the artist. Thus Duchamp's urinal is the precursor of what today we call "found art."

Today, we—and that includes the man in the street—are much more comfortable with the concept of found art. We are simply invited to judge and appreciate it as we would judge and appreciate any conventional work of art; we can take it or leave it and often, possibly without even realizing it, we take it.

A sculptor might labor for months carving a contorted abstract, gnarled and richly textured; alternatively, nature might do it for him

in a piece of driftwood. If he discovers such an object and it suits his purpose exactly, is it not art? A group of crushed Coke cans would be a difficult thing to create in a studio; but if that is what the artist had in mind, what is wrong with locating and displaying the real thing?

What is important here is the artist's intention, not only his sensibility and sensitivity. Never mind the short cut; simply by choosing an object, removing it from its original environment, and representing it within a fresh context he will be saying something to us. What he is saying may be profound or facile, but that's what art judgment is about.

Anonymous snapshots are, as it happens, a treasure trove of found art; their very ambiguity provides them with a great potential. Something will attract some of us, inevitably, to a particular snapshot; we may know what it is, or we may not. Whether that snapshot can be metamorphosed into art will depend upon our collective sensibility, our conviction, and our purpose.

So far, in this book, we've defined the qualities inherent in many snapshots and revealed how contemporary photographers have purloined, exploited, and amplified them. We've looked at the snapshot comparatively and aesthetically in an attempt to show that the humble snapshot can possess the qualities we ordinarily look for in a work of art—the power to communicate, the authority to demand attention, compositional niceties, a transcendent depth to draw us into the image and beyond it. Undoubtedly a snapshot may possess artistic form, however indefinable the sum of its parts.

We finally arrive, then, at a fundamental question: "Can we (yes *you*, the reader) use snapshots to share in an artistic experience?"

Well, yes and no. It surely depends upon what you might wish to say, or do, or achieve. Experimenting will at least provide a start, although if you need me to tell you this you have good reason to be discouraged. From a pile of a hundred or so anonymous snapshots, for example, are there any that attract you in some way? How profoundly? To what extent are you prepared to think about them? As I explained earlier, confronting an isolated, anonymous snapshot places it in a challenging new context. It becomes *yours*. Isolate it further by placing it in a mat. Enlarge it. Project it huge on a wall. Analyze it; look into it; wonder about it. You own it—now *possess* it! You may become involved in an aesthetic experience.

But while we might look at a snapshot in isolation, we cannot disregard snapshots *collectively*. Snapshots, as individual, unique

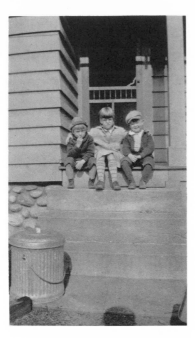

209. *Snapshot. Toned print. American. 1920s. The most fundamental way in which to appreciate an anonymous snapshot is to allow your intuition to respond to it as an object or as an image. The important thing is whether it grabs you or not.*

210. *Enlarged snapshot. Many snapshots reveal much more if they are enlarged, cropped, and isolated in a mat. Enlarging can bring out details and impart authority.*

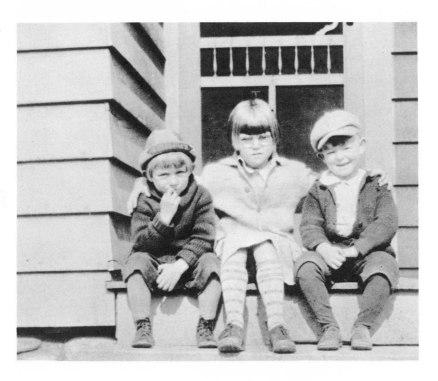

slivers of time, relate to one another. If one snapshot happens to communicate something to you more powerfully than it should have a right to, it is because other snapshots exist. That veritable ocean of snapshots makes it possible for you to react to and isolate certain examples of their kind.

And this, perhaps, is the essence of the concept of snapshots as "found art": one's intimate knowledge of and feeling for snapshots and snapshot language, above and beyond a sympathy for artistic form. Thus ironic or fateful juxtapositions will suggest themselves, enabling you to embolden your statement.

An apt example here is *Five Found Photos* by Geoffrey Hendricks (Printed Editions, New York, 1979), an elegant little booklet in which we first see five uncaptioned photographs: a butcher in his shop; a group of workmen erecting a power pylon; a burning shed; half a

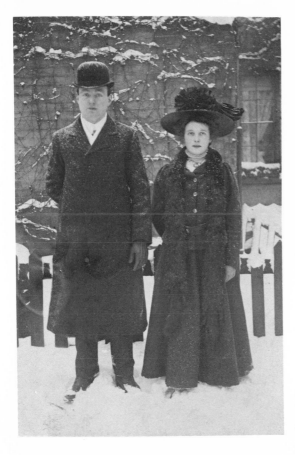

211. Snapshot. English. 1908. A splendid image in its own right, this snapshot bears an uncanny similarity to the Benjamin Stone photograph (Plate 212). Discovering "twin images" can be a diverting and instructive game.

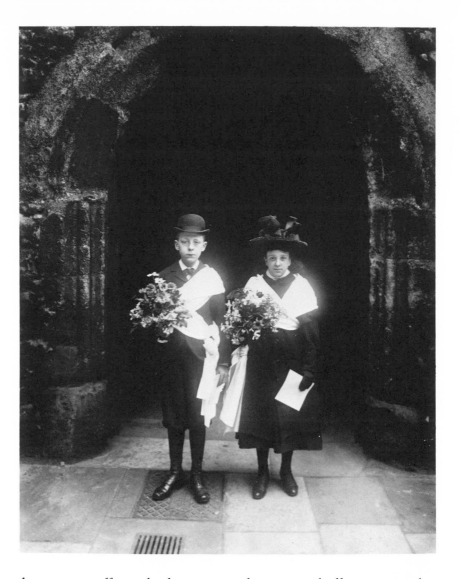

212. *Sir Benjamin Stone.* Maundy Thursday Ceremony. *English. 1898. City of Birmingham Public Libraries Department. Compare the two children with the couple in the previous snapshot (Plate 211).*

dozen army officers drinking tea; and a group of officers, somewhat drunk, slumped on a settee. None of the photos appears to be visually or logically associated with any of the others, yet one has the feeling that each is vaguely linked. Finally, on the last page of the booklet, we have Hendricks's explanation: "Last summer in Germany, rummaging through flea markets, I collected some old postcards and photographs. The collection was made casually just picking out what struck my fancy. One night I noticed certain photographs were of the same

people. Other cards seemed to go together because of similar structural elements. I began to group and regroup the material, pairing images visually, narratively, and numerically, seeing contrasts and similarities of form, subject, location, time, or emotion. Sometimes there were surprises. These five cards are one distillation from this process. They might imply a story, or a dream, perhaps a souvenir of a summer abroad. They are for reflection."

Thus far we've considered only unmanipulated snapshots as a means to make aesthetic statements—a concept that is as bold as it is pure. The field, though, widens considerably when we begin to interfere with this found material. Photographic images carry within their emulsion a persuasive authority that is not necessarily diminished when out of context; when the real meaning is lost, something will always fill the void. This property is exploited in an age of loosened family ties and loneliness; it is not unknown for people to acquire anonymous snapshots and pass them off as their own. I know a young man whose Manhattan apartment is decorated with the framed snapshots of his "instant family" as he calls them. Taking our cue from his need, we might use a series of snapshots to fake an imaginary biography.

Indeed, this is a common ploy with the current wave of conceptual artists. As a school which stresses the supremacy of content over form, the photograph was promptly appreciated in its raw state by the conceptualists as highly communicative and evocative material. Thus photographs and particularly snapshots are a common staple—along with other associative visual and verbal ephemera—of documentary collages and assemblages in which experience, environment, people, and objects are projected.

The most dedicated conceptualist users of the snapshot are the auto-artists, who are not painters of automobiles but those who generate memories from documents, genuine and fabricated, as a means of asking who they are and how they came to be that way. The person they know least and the one they know most is the subject matter of their art, and snapshots provide many of the answers they seek. Not infrequently, the snapshots themselves are fabricated. The French artist and photographer Christian Boltanski, in an attempt to recapture the reality of his past—from which very little documentary evidence survived—was driven in the end to assemble fake snapshots of a succession of youthful models from the ages of three to seventeen, all representing himself. The resulting work, *Eight Photographic Portraits of*

Christian Boltanski (213), is extraordinarily persuasive and its veracity is questioned only by observant viewers who notice that the location, a garden path, is virtually unchanged in all the snapshots despite the implied passage of time.

213. *Christian Boltanski.* Eight Photographic Portraits of Christian Boltanski. *French. c. 1970. In an attempt to reconstruct memories of his past, of which little documentary evidence had survived, the artist assembled a sequence of fake snapshots to create a photo-biography of fourteen years of his life.*

Christian Boltanski at the age of 3, June 7, 1947

Christian Boltanski at the age of 5, March 12, 1949

Christian Boltanski at the age of 7, July 6, 1951

Christian Boltanski at the age of 9, June 20, 1953

*Christian Boltanski at the
age of 10, May 3, 1954*

*Christian Boltanski at the
age of 11, August 20, 1955*

*Christian Boltanski at the
age of 14, April 25, 1958*

*Christian Boltanski at the
age of 17, August 5, 1960*

But it remained for San Francisco photographer William DeLappa to extend "snapshot theft" to its limit. In 1977 at the International Center of Photography in New York, he exhibited a series of what appeared to be 11″ x 14″ and 16″ x 20″ maple-framed enlargements of family snapshots, circa 1950. People paused to smile at the camera,

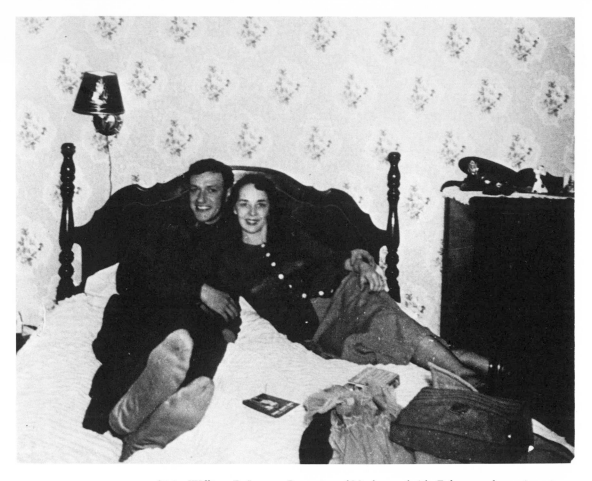

214. *William DeLappa.* Portraits of Violet and Al. *Fake snapshots. American. c. 1977. Using models, DeLappa created an album of fake snapshots and, consequently, fake memories of a fictional couple called Violet and Al.*

their eyes black caverns of shadow; a couple, Violet and Al, celebrated Christmas, posed on a double bed, cut a cake in the kitchen, and clowned for the photographer (214). The photos bore chips and creases and scratches and the various other blemishes of well-thumbed mementoes.

They were, in fact, fakes—not merely fake snapshots, but fake memories—artfully and disturbingly contrived to deceive and confuse. Whether DeLappa's "Timewarp" images are a daring aesthetic device, as they were hailed at the time, is arguable, but he certainly

demonstrated the snapshot's ambiguous qualities in a totally unexpected way.

Obviously the character of a snapshot, as with some other categories of photographs, can change in a most startling manner according to how it is viewed. Susan Sontag attributes this quality to "the aestheticizing tendency of photography." This chameleon quality is very well demonstrated in the work of Yugoslav Braco Dimitrijevic, an innovative artist who photographs casual passersby at random in the street and then grossly enlarges the snapshots into gigantic public photomurals. Thus an anonymous person is projected, overnight, into the realms of heroic celebrity, not because of any special qualities of

215. *Braco Dimitrijevic. Snapshot. Yugoslav. 1972. The metamorphosis of a snapshot. The artist snapped this casual passerby in a Dusseldorf Street, one day in 1972.*

216. *Braco Dimitrijevic.*
Photo mural. Twenty-
four hours later the snap-
shot had been heroically
enlarged, and the anony-
mous passerby becomes a
public image.

his own but simply through the transformation of a snapshot. As Marshall McLuhan noted, "The medium is the message."

Predictably, perhaps, a new role has emerged, that of the artist photographer, occupying a void between both media and owing not a little to the snapshot ethic. Its basis rests on the truism that while there may be *an* image of a subject, there can be no single image of anything. Every aspect of reality can be recorded from an infinite

number of viewpoints; no single viewpoint, at any moment, can tell the whole truth. Followers of this view think in terms of multiple images. When two or more images come together, several things can happen. The meaning of each individual image can change. A new meaning can emerge. And when viewed together, photographic depth is replaced by a single plane. In other words, several images can become a single image.

The American Ray K. Metzker is one of many contemporary photographers who have enlarged on this phenomenon, synthesizing uniquely complex images by multiplication: negatives printed together, overlapped prints, and repetition and manipulation of the same or similar negatives on a single large sheet (217). The effect is macrocosmic, visually and intellectually satisfying. Photographic material is used, in much the same way as a painter uses tubes of paint, to re-express the camera's single, rigid viewpoint.

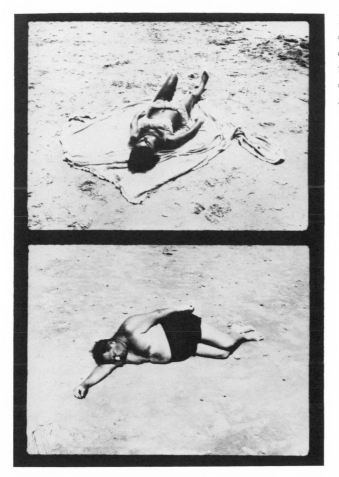

217. *Ray K. Metzker. Untitled. American. c. 1969. Two images become one, and the different perspective depths of each photo merge into a single plane. A similar technique can be used with pairs and multiples of snapshots.*

In a less technical context, photographic sequences offer a wide-open area of creativity and one that can be explored with snapshots. The most common sequence is of course the narrative, usually a succession of anecdotal images which tell us more than a single frame can. But sequences need not be pragmatic. Sometimes sequences and pairings can offer more than mere additional information about the subject; odd and hitherto unrelated snapshots can come together as though preordained, inviting speculation. A simple pairing of two snapshots (218) achieves exactly that: same scene, same time, same little girl, but two different women. Why? Which one is the mother? Games can be played, too, with pairings consisting of a snapshot and its twin—an unrelated image but with an uncanny visual similarity with the snapshot (211, 212).

This is using the snapshot as a kind of launching pad for the imagination. There is room on the pad for any number of creative artists working in many modes—even novelists, for snapshots have already provided the inspiration for literary fiction. In *A Family Album* (John Calder, London, 1978), David Galloway has taken half a dozen snapshots and developed them, as it were, in his own imagination, to produce a somewhat eccentric novel. And one can also foresee snapshot poetry: *Dad, scrubbed pink-faced from the bath/Mom, smooth that wrinkle in your stocking/And Auntie Bea, with sun-plucked eyes/Move a little left, closer—yes, that's it/Good. Should have mowed the lawn./Now uncle's trying not to yawn/Oh quick, there's little Timmy/Snap him! What a hoot!*

But of all the groups that have carved chunks from snapshot territory to call their own, the most publicized expropriation has been made by representational artists. Photography has not, interestingly, attracted many artists to the medium, perhaps because the very principle of photography imposes a fundamental limitation on self-expression. Before a photograph can be taken, no matter how abstract, surreal, or symbolic, there *must* be a subject—a real scene, person, object, or natural effect—something that exists in the world the moment the shutter is sprung. With this constraint, photography can hardly serve as the ideal "means to self-expression," which must operate in a realm as limitless as the human imagination.

Frustrated on this count, some artists have turned to the photograph as a window to reality. Such artists have come to be known as Photo Realists or Super Realists.

218. *Snapshots. American. 1940s. The two images together are much more interesting than the individual snapshots. And enigmatic, too. It's the same child, but which of the two women is the mother?*

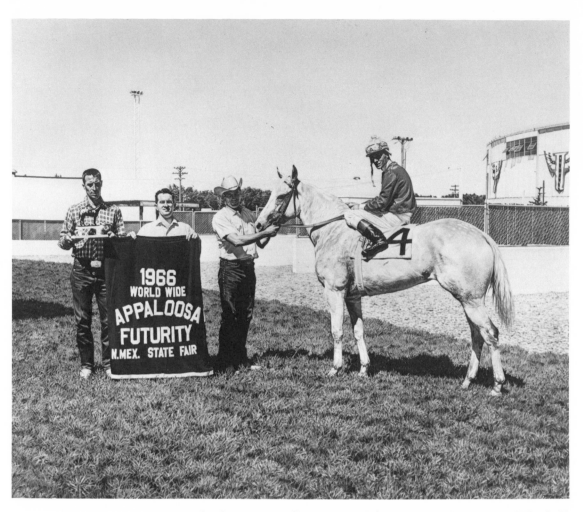

219. *Richard McLean. Albuquerque. Oil on canvas. American. 1972. O.K. Harris Works of Art, New York. A large (50″ × 50″) Photo Realist translation from a snapshot.*

The philosophy of this school is that a painter's experience of reality, basically a lifelong bombardment by ready-made, two-dimensional photographic, cinematic, and electronic images, precludes any pursuit after "real" images. Logically, the artist's subjects must be illusions, of which the most available are photographs. The artist's role as an arbiter of reality, they believe, is finished. Instead he must choose a form which avoids any subjective manipulating whatsoever. His work

must be totally noninterpretive, devoid of the slightest personal comment and emotional response. A complete lack of interest in the subject, too, is held to be an advantage.

Based on what the camera sees rather than what the eye observes, Photo Realism is a misnomer. More accurately the styles are variations of Pop Art, which aptly recycles ordinary objects and visual conventions like Warhol's soup cans and Brillo boxes, and Roy Lichtenstein's blowups of comic art. Few artifacts more deftly symbolize today's mass production society than photographs, and Photo Realists are really no more than laggard followers of Warhol *et al.*

But to say that the Photo Realist style is corrupt, facile, faddist, and futureless (it is all these and more) is not to malign the individual work of several of its adherents who, with wit, perception, and a *real* artist's eye, have created works which could not have been realized in any other style.

Inherent in every photograph, and that includes snapshots, is the photo-freeze effect—the mechanical ability of the camera to stop motion. At the technical extreme, even fast motion can be frozen without blurring and with no significant loss of depth; you might say that the camera is theoretically capable of capturing a single frame of time.

This freezing effect even applies to what we usually consider to be stationary subjects, such as portraits. The American artist Chuck Close exploits this in many of his technically breathtaking, heroic-size portrait heads, in which he reproduces, and even heightens, the nuances of photographic depth from the sharpness of the eyeball to the slightly off-focus nose and back of the ear—dimensions that would be difficult, if not impossible, to observe on an ordinary 8″ x 10″ photo portrait. Close spends up to a year painting every hair, bristle, and pore on his nine-foot-high portraits.

Another exponent of Photo Realism paints life-size horses so real they almost gallop off the canvas, yet he professes to hate the animals. Most disciples of this currently fashionable genre sweat for months at a time in the heat of their projector lamps to create what unsympathetic critics have labeled "neutered art" and "the ultimate in banality." More benevolent commentators regard these paintings as metaphors for the pointlessness of life itself.

Snapshots, as you have seen, have the capacity to multiply, clone, and mutate; and they are everywhere around us, lying dormant like

trillions of seeds. Despite the ingenuity already expended, few would be bold enough to say that the aesthetic potential of snapshots has been exhausted. On the contrary, I believe we've merely scratched the emulsion of this vast resource.

But while we may use the snapshot as a springboard for paintings, to create fake personalities, to fabricate biographies of people and families, to fashion fantasies and illusions, to synthesize new images, to inspire fiction and poetry, we should recognize that the snapshot has a persuasive claim to its own unique identity.

Perhaps the ultimate view of snapshots is the purist one, that they are a class apart and bear no comparison with any other art form, even with other photographs. One's appreciation would follow from a quest for revelation rather than comprehension; to respond to snapshots by intuition rather than by intellect. As Lisette Model so lucidly puts it, "If I were to print a book of snapshots, I would do it in its own spirit. On the front page would be one snapshot, and in the inside pages would be loosely distributed images, without introduction, without philosophy, without explanations, without captions, so that for once people would be free to discover for themselves, without being told what to see."

And that is how I will close this book—with a portfolio of ten anonymous snapshots I chose from my collection simply because the images appealed to me. Feel free to discover their charm, their mystery, even their meaning, for yourself.

A
SNAPSHOT
PORTFOLIO

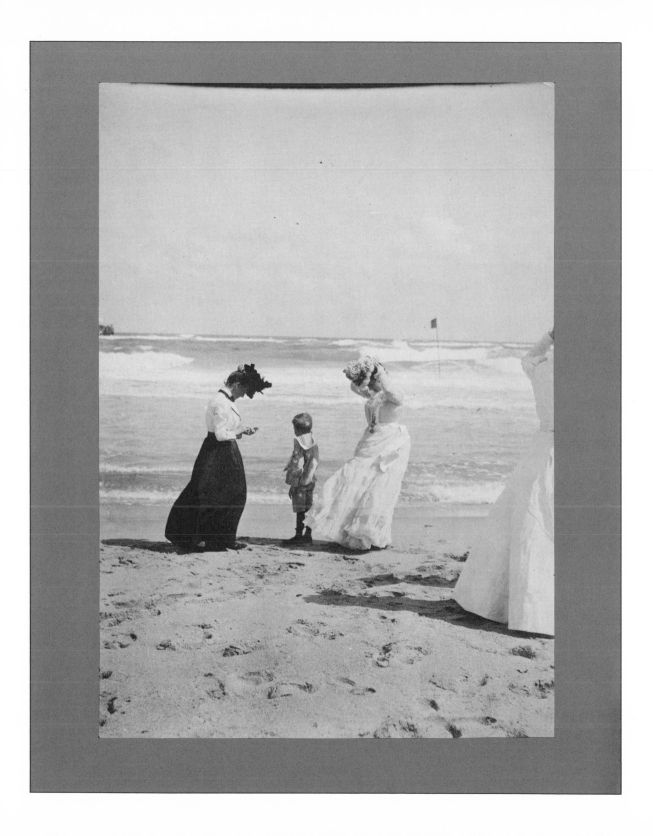

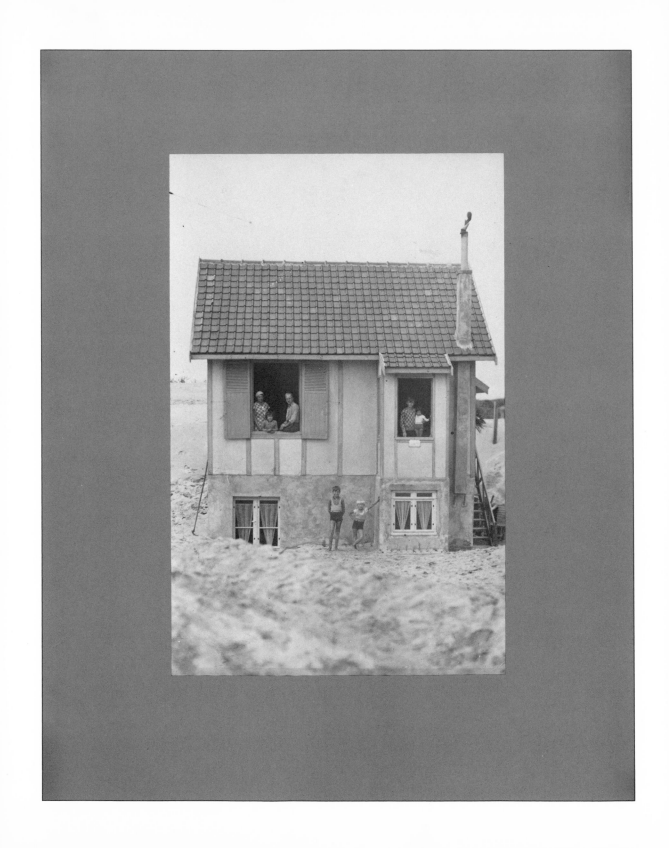

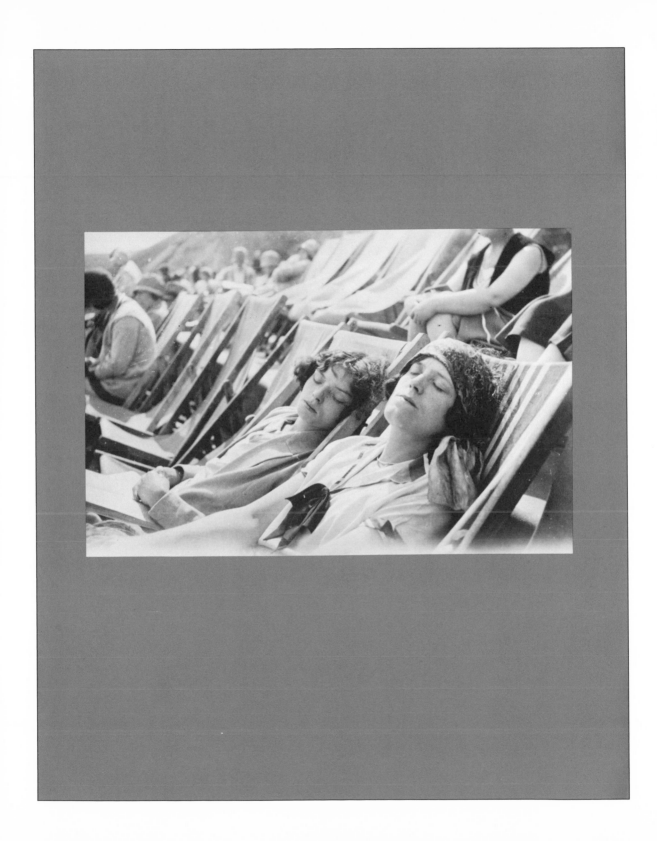

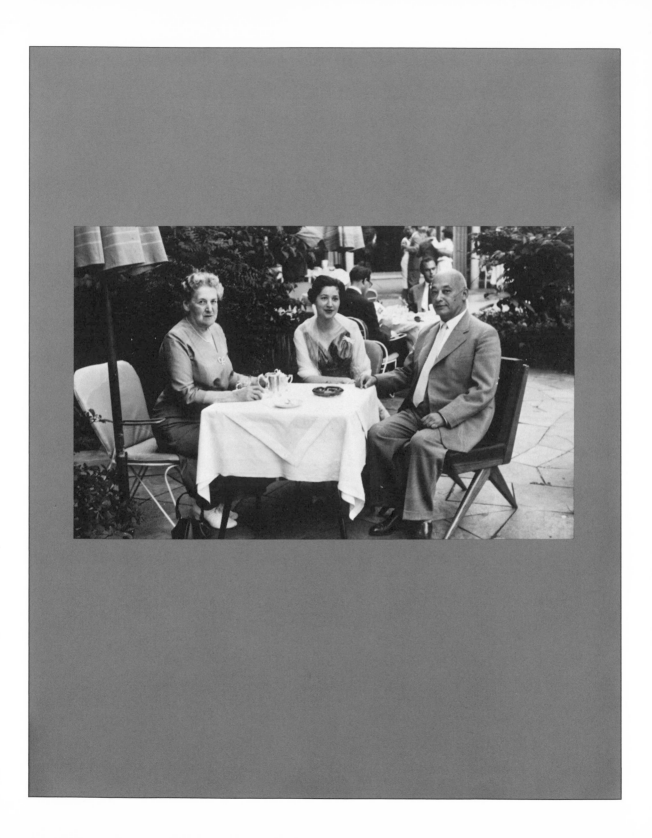

Further Reading

Akeret, Robert U. *Photoanalysis—How to interpret the hidden psychological meaning of personal photos.* New York: Peter H. Wyden, Inc., 1973.

Battcock, Gregory, ed. *Super Realism—A Critical Anthology.* New York: E.P. Dutton & Co., 1975.

Bayer, Jonathan. *Reading Photographs—Understanding the Aesthetics of Photography.* New York: The Photographers' Gallery/Pantheon Books, 1977.

Blodgett, Richard. *Photographs: A Collector's Guide.* New York: Ballantine Books, 1977.

Coe, Brian. *The Birth of Photography—The story of the formative years.* London: Ash & Grant, 1976.

———. *Colour Photography—The First Hundred Years 1840–1940.* London: Ash & Grant, 1978.

Coe, Brian, and Gates, Paul. *The Snapshot Photograph—The Rise of Popular Photography, 1888–1939.* London: Ash & Grant, 1977.

Dennis, Landt and Lisl. *Collecting Photographs.* New York: E. P. Dutton, 1977.

Gernsheim, Helmut and Alison. *The History of Photography.* London: Thames and Hudson, 1969.

Gilbert, George. *Photography: The Early Years.* New York: Harper & Row, 1980.

Graves, Ken, and Payne, Mitchell. *American Snapshots*. Oakland, California: The Scrimshaw Press, 1977.

Green, Jonathan, ed. *The Snapshot*. Millerton, New York: Aperture, 1974.

Hirsch, Julia. *Family Photographs—Content, Meaning and Effect*. New York: Oxford University Press, 1981.

Lucie-Smith, Edward. *The Invented Eye—Masterpieces of Photography, 1839–1914*. London: Paddington Press, 1975.

Malcolm, Janet. *Diana & Nikon—Essays on the Aesthetic of Photography*. Boston: David R. Godine, 1980.

Meisel, Susan Pear. *The Complete Guide to Photo-Realist Printmaking*. New York: Louis K. Meisel Gallery, 1978.

Norfleet, Barbara. *Wedding*. New York: Simon and Schuster, 1979.

Scharf, Aaron. *Art and Photography*. London: Allen Lane: The Penguin Press, 1968.

Sontag, Susan. *On Photography*. New York: Farrar, Straus and Giroux, 1973.

Szarkowski, John. *Mirrors and Windows—American Photography Since 1960*. New York: Museum of Modern Art, 1978.

———. *Looking at Photographs—100 Pictures From the Collection of the Museum of Modern Art*. New York: MOMA. 1973.

Thomas, Alan. *Time in a Frame—Photography and the 19th-Century Mind*. New York: Schocken Books, 1977.

Trachtenberg, Alan, ed. *Classic Essays on Photography*. New Haven, Connecticut: Leete's Island Books, 1980.

Walsch, George; Naylor, Colin; and Held, Michael, ed. *Contemporary Photographers*. New York: St. Martin's Press, 1983.

Welling, William. *Collectors' Guide to Nineteenth-Century Photographs*. London: Collier Books, 1976.

Witkin, Lee D., and London, Barbara. *The Photograph Collector's Guide*. New York: New York Graphic Society, 1979.

SNAPSHOT OR IMITATION? Of the eight images shown in Plate 208, A, F, and H are ordinary, anonymous snapshots. The others are professional studies which are in important collections or which have been published: B—William Eggleston, *"Gulfport, Mississippi,"* 1976. C—Gardner Botsford, *Untitled*. D—Joel Meyerowitz, *Untitled*. E—Tod Papageorge, *Santa Fe, New Mexico*, 1969. Coll. Museum of Modern Art, New York. G—William Eggleston, *"Tallahatchie County, Mississippi,"* 1976.

Index